PENGUIN CLASSICS

ON PAINTING

Humanist, poet and scholar, architect and art theorist, engineer and mathematician, LEON BATTISTA ALBERTI was the archetype of the Renaissance 'universal man'. He occupies an important place in the history of literature as well as of art and architecture in fifteenth-century Italy. Born in Genoa in 1404, he belonged to one of the wealthy merchant-banker families of Florence, who had been exiled from Florence by the oligarchical government then dominated by the Albizzi family. Shortly after Alberti's birth the family moved to Venice. Alberti was sent to boarding school in Padua at the age of ten or eleven, where he was given a classical Latin education. He then moved to the University of Bologna and probably graduated in canon law in 1428. He subsequently entered the service of leading churchmen, becoming a secretary in the Papal Chancery in Rome. He took holy orders and, from this point on, the church provided him with his main source of income, although his interests and activities were predominantly secular.

Returning to Florence in 1434, his close associations with the sculptor Donatello and the architect Brunelleschi led to the book *On Painting* (1435) in which he set forth the principles to be followed by the painter. His instructions on perspective and narrative had an immediate and profound effect upon Italian painting and relief work. He then began to turn towards architecture and in 1446 began his first important building, the transformation of the old church of S. Francesco at Rimini. Around 1450 he produced his most substantial treatise, the *De Re Aedificatoria*, a comprehensive survey of the art and science of building. Among the churches designed by him are San Francesco at Rimini (*c.* 1450), the façade of Santa Maria Novella in Florence (1458), San Sebastiano (1459) and Sant' Andrea at Mantua, which was designed in 1470-71 and completed after his death. He died in Rome in 1472.

A graduate of Oxford University, CECIL GRAYSON became lecturer in Italian at Oxford in 1948 and was Serena Professor of Italian Studies and Fellow of Magdalen College from 1958 to 1987. He was also visiting professor at the universities of Yale, California, Perth

and Cape Town. Honoured by numerous Italian academies, he received the Premio Internazionale Galileo in 1974 and was made a Commander of the Order of Merit in 1975. As the leading authority on Alberti's written work, his edition of Alberti's *Opere Volgari* (1960, 1966 and 1973) remains the standard point of reference. He also published on Dante's poetry and the history of the Italian language. He was awarded the CBE in 1992. Cecil Grayson died in 1998.

MARTIN KEMP was educated at Windsor Grammar School and Cambridge University, where he studied Natural Sciences and the History of Art. He subsequently studied at the Courtauld Institute of Art. He has taught at the universities of Dalhousie, Canada, Glasgow and St Andrews, where he was Professor of Fine Arts. He has worked at the Institute for Advanced Study in Princeton, the Institute of Fine Arts in New York and Cambridge University (as Slade Professor) and the Getty Institute in Los Angeles. Since October 1995 he has been Professor of the History of Art at the University of Oxford. His publications include *Leonardo da Vinci: The Marvellous Works of Nature and Man* (1981), *The Science of Art: Optical Themes in Western Art from Brunelleschi to Seurat* (1990), *Behind the Picture: Art and Evidence in the Italian Renaissance* (1997), *Visualizations: The "Nature" Book of Art and Science* (2000) and *The Oxford History of Western Art* (2000).

LEON BATTISTA ALBERTI
On Painting

Translated by
CECIL GRAYSON
With an Introduction and Notes by
MARTIN KEMP

PENGUIN BOOKS

PENGUIN BOOKS

Published by the Penguin Group
Penguin Books Ltd, 80 Strand, London WC2R ORL, England
Penguin Group (USA) Inc., 375 Hudson Street, New York, New York 10014, USA
Penguin Books Australia Ltd, 250 Camberwell Road, Camberwell, Victoria 3124, Australia
Penguin Books Canada Ltd, 10 Alcorn Avenue, Toronto, Ontario, Canada M4V 3B2
Penguin Books India (P) Ltd, 11 Community Centre, Panchsheel Park, New Delhi – 110 017, India
Penguin Books (NZ) Ltd, Cnr Rosedale and Airborne Roads, Albany, Auckland, New Zealand
Penguin Books (South Africa) (Pty) Ltd, 24 Sturdee Avenue, Rosebank 2196, South Africa

Penguin Books Ltd, Registered Offices: 80 Strand, London WC2R ORL, England

www.penguin.com

This translation first published by Phaidon Press 1972
Published in Penguin Classics 1991
Reprinted with revised Further Reading 2004

· 038

Filmset in 10/12 pt Monotype Bembo
Typeset by Datix International Limited, Bungay, Suffolk
Printed and bound in Great Britain by Clays Ltd, Elcograf S.p.A.

ISBN-13: 978–0–140–43331–9

www.greenpenguin.co.uk

Contents

Introduction

I consider it a great satisfaction to have taken the palm in this subject, as I was the first to write about this most subtle art. (*On Painting*, 63)

When a delegation of Florentines led by Lorenzo de' Medici, 'Il Magnifico', visited Rome in 1471 to pay respects to the newly elected Pope, Sixtus IV, they were conducted on a learned tour of the Forum Romanum by the resident genius of the ancient city, Leon Battista Alberti. For the generation of Lorenzo, particularly for the accomplished scholars and philosophers in his circle, the sixty-seven-year-old Alberti was a heroic figure in the 'rebirth' of literature and the visual arts. The great philosopher–poet Angelo Poliziano in his dedication to Lorenzo of the first printed edition of Alberti's treatise on architecture, *De Re aedificatoria* (1486), gave glowing testimony to Alberti's reputation: 'he was a man of rare brilliance, acute judgement, and extensive learning . . . Surely there was no field of knowledge however remote, no discipline however arcane, that escaped his attention.'[1] Alberti was revered as a leader in the revival of the true Latin tongue of the ancients in a variety of literary modes, as a pioneer in the refinement of the Italian vernacular so that it might be fit to stand alongside Latin, as an authority on the arts and sciences and, above all, as a moral exemplar in word and deed. It was in this last guise that Alberti featured as a worthy protagonist for Lorenzo in the *Camaldulanian Disputations* by Cristoforo Landino, another of Il Magnifico's

literary luminaries. In the course of the dialogue Alberti resolutely argues that the contemplative virtues of a scholarly life devoted to the pursuit of wisdom are superior to active engagement in the hurly-burly of political action.

It would have surprised Alberti and his many Renaissance champions to find his small treatise on painting promoted in later ages as the most significant of all his writings. Genuine originality – and few books can have been as unprecedented as *On Painting* – was less valued as a crucial measure of literary achievement in Alberti's own day than it has been in our century. To be regarded as 'a great imitator of the ancients' was at least as important a criterion of excellence in the Renaissance as to be a promulgator of outright novelties. From the perspective of his own era, his considerable series of moralizing yet entertaining dialogues on themes of Stoic virtue in individual, family and civic life may be seen as occupying the central place in his literary career. They succeed in transposing the ethical codes of Roman authors, above all Cicero, into the context of fifteenth-century Italy. Alberti's imaginative compositions in poetry and prose were prized as exemplary revivals of ancient genres, although they are little read today. And his *De Re aedificatoria* was both a homage and challenge to the treatise by the ancient Roman architect, Vitruvius. By contrast, *On Painting* has no precedent. Its originality of content, as the first known book devoted to the intellectual rationale for painting, does not mean, however, that it is atypical amongst Alberti's writings with respect to language, form or underlying message. There is probably no author who more consistently aspired to shape his own life and work – and our concept of life and work in general – into a coherent whole. The central purpose was the cultivation of *virtù* (the power of individual talent sustained by moral worth and strength of will) as a bulwark against *fortuna* (the capricious whims of fate in the vagaries of worldly affairs). The true guide towards this end was the study of the natural order of things in God's creation. It is within these contexts of human virtue and natural order that *On Painting* is to be understood.

SCHOLAR AND CITIZEN

A major shaping factor in Alberti's attitude to life was the fate of his ancestors. He was an illegitimate son in a distinguished and well-to-do Florentine family, whose members had been successively sent into political exile during the years following 1387. Battista – a good Florentine name, since St John the Baptist was a patron saint of the city – was born in Genoa in 1404, and educated in the major north Italian centres of learning, first in Padua at the humanist school of Gasparino Barzizza, where he acquired fluency in Latin letters, and subsequently at the University in Bologna, where he studied jurisprudence. During the course of his studies he also laid the foundations of his knowledge of those precise sciences, particularly mathematics and optics, that were to give him such an exceptional range of mind. By the age of twenty he had mastered the classical heritage to such effect that he was able to compose a Latin comedy, *Philodoxeos*, that purported to have come from the pen of an ancient Roman playwright, Lepidus.

The death of his father in 1421 and subsequent family squabbles over his right to an inheritance left Alberti uncertainly placed and coloured his views on the inconstancies of everyday life. His reaction was to concentrate on the enduring virtues of learning, and in 1428 he composed a treatise, *De Commodis literarum atque incommodis* (*On the Advantages and Disadvantages of Scholarship*), that reflects his disillusionment with the political and social vicissitudes of human affairs. This tract initiates what was to become a continuing dialogue between his devotion to learning for its own 'immortal' rewards and his instinctive sense that wisdom should be applied to the good of human life in the actual community. An extended series of works – including his *Teogenius, Profugiorum ab aerumna* (*On the Retreat from Hardship*, otherwise known as 'On the Tranquillity of the Mind', a dialogue set under the Dome of the Cathedral), *De Iciarchia* and, his greatest work in the vernacular, the four books of *Della Famiglia* composed between 1433 and 1441 – use various spokesmen from within and outside his own family circle to parade a range of arguments in favour of the

contemplative and active lives. It is unwise to assume that any of the spokesmen in the semi-fictionalized dialogues precisely express Alberti's own ideas, and the balance in his own beliefs appears to have shifted during different phases of his own public career, but the central tenets of his practical philosophy do emerge quite clearly. At the heart of his beliefs lies a conviction that it is our human duty to cultivate our individual *virtù* in those praiseworthy and improving pursuits that stand apart from *fortuna*: 'fortune cannot give us various things . . . character, virtue, letters or any skill. All these depend on our diligence, our interest.'[2] He steers a middle course between total immersion in such environments of the here-and-now as the stormy seas of commerce or the rough-house of politics, and a complete monastic withdrawal into a life of abstract contemplation. He was not predisposed towards philosophical abstractions for their own sakes, and was continually concerned to relate his underlying sense of God's order to the actual behaviour of the individual in society. One of his spokesmen advocates that certain of the arts provide an arena in which profit and virtue can live together:

There are . . . activities in which the powers of body and mind function together to bring profit. Such are the occupations of painters, sculptors, musicians and others like them. All these ways of making a living, since they depend mainly on our personal powers, are what you call arts, and do not go down in shipwrecks but swim away with our naked selves. They keep us company all our lives and feed and maintain our name and fame.[3]

Through the circumstances of his illegitimacy and lack of guaranteed access to Alberti funds, Battista was himself forced to face the dilemma of reconciling a life dedicated to disinterested learning with the need to make a living. The solution, as for many other Renaissance humanists, lay within the system of patronage and clerical service. As an outstanding young man of letters, well versed in canon law, he was taken into the service of senior churchmen, perhaps travelling with Cardinal Albergati in France and neighbouring countries. By 1432 he was acting as secretary to

Biagio Molin, Patriarch of Grado, who was in charge of the papal chancery in Rome. He was appointed as a papal 'abbreviator' (an official clerk, writer of briefs, etc.), a post that he held until its abolition by Paul II in 1465. Through the good offices of Eugenius IV he was sanctioned to receive the ecclesiastical benefices of S. Martino a Gangalandi in the diocese of Florence, and subsequently of Borgo S. Lorenzo in Mugello from Nicholas V. He also became a canon of Florence Cathedral. It was in the entourage of Eugenius that he returned in 1434 to Florence, 'to this most beautiful of cities from this long exile in which we Albertis have grown old'.[4] The ban on the Albertis had been lifted in 1428, and Leoh Battista was to live in the city for substantial periods during the next decade. The revelatory impact of the achievements in architecture, sculpture and painting of Filippo Brunelleschi, Lorenzo Ghiberti, Donatello, Luca della Robbia and Masaccio did much to precipitate Alberti's decision to write *De Pictura* in 1435 and to translate it into Italian a year later, with a dedication to Brunelleschi.

From his base of papal preferment and remuneration he was able to travel widely and to pursue an independent career in letters, attracting the patronage of such leading Renaissance princes as Leonello d'Este of Ferrara and the Gonzaga of Mantua. His prolific literary production embraced the dialogues on social philosophy, treatises on diverse moral and practical themes, collections of edifying tales and fables in the manners of Lucian and Aesop, a Latin satire on the disorder arising from capricious rule (*Momus* or 'The Prince'), love poetry and the first grammar of the Italian tongue. Unusually for a humanist he was also active in scientific fields, though, as in his philosophy, his prime concern was with such 'applied' science as was relevant to particular human endeavours. A group of works may be characterized as employing mathematical systems to perform specific tasks: the *Ludi matematici*, in which he applies basic mathematics to various problems in the measurement of distances, dimensions and weights; the *Elementa picturae*, which describes some basic geometrical figures and their transposition on to foreshortened planes; the

Descriptio urbis Romae, in which he tells how he has used a surveying disc similar to an astrolabe to make a measured survey of the ancient city; *De Statua*, which deals with human proportions and a device for replicating dimensions in figure sculpture; and *De Componendis cifris*, which explains his invention of a highly effective code wheel. The important instructions on perspectival design in Books I and II of *On Painting* may be recognized as part of this endeavour to endow practical skills with a mathematical base.

His vision of mathematical order expressed through tangible activities found its perfect realization in the work of the architect:

Him I consider architect, who by sure and wonderful reason and method, knows how to devise through his own mind and energy, and to realize by construction, whatever can most beautifully be fitted out for the noble deeds of men.[5]

His ten-part treatise on architecture, *De Re aedificatoria*, a draft of which was presented to Nicholas V in or before 1452, takes its inspiration in form and content from Vitruvius's *Ten Books on Architecture*, the only treatise on any visual art to have survived from antiquity. But Alberti's substantial book is far from a work of imitation. Vitruvius's material is critically subjected to a radical reordering in both presentation and underlying logic; and new considerations are brought to bear in the light of Renaissance circumstances. It was in this treatise, as we will see, that he arrived at his mature definition of beauty.

Architecture played an increasing role in the later part of his life, as he was presented with opportunities to put his theories into practice. Commissions from rulers and wealthy individuals outside Rome allowed him to exercise his talents on a series of buildings that survive today. Four major church projects were undertaken: the clothing of S. Francesco Rimini in Roman garb as the 'Tempio Malatestiano' between 1450 and 1470 for Sigismondo Malatesta; the conception for Lodovico Gonzaga in Mantua of the Greek-cross church of S. Sebastiano, probably commissioned in 1459, and of the monumental basilica of S. Andrea, designed in

1470–71; and the grand temple-front imposed on the Florentine church of S. Maria Novella in honour of the Rucellai family from 1458 onwards. The domestic buildings that can be most closely associated with Alberti are the Florentine palace and loggia of the Rucellai, for whom he also undertook the chapel in S. Pancrazio that contains the family tomb designed in emulation of the Holy Sepulchre in Jerusalem. Under the humanist Pope Nicholas V his was a significant voice behind the ambitious plans to reshape Rome with a dignity and coherence worthy of its pagan past and Christian present. His voice as a consultant might also be discerned behind that most delightful piece of Renaissance town-planning, Pius II's reshaping of the centre of Pienza.

In these and other architectural enterprises he placed his sense of ordered proportion and detailed knowledge of the grammar of ancient Roman buildings in the service of contemporary requirements. If we may describe Brunelleschi as the architect–engineer who refined the native Tuscan style according to the lessons of the ancients, we could characterize Alberti as the architect–scholar who showed how the ancient grammar of design could become directly relevant to his own age. In the process Alberti squared that most difficult of circles: he acted with impeccable reverence to the past and at the same time exercised his originality to meet present needs.

NATURE AND ORDER

Man is the scale and measure of all things. (Protagoras, quoted in *On Painting*, 18)

Alberti adopted what may be broadly described as a Christianized Stoic viewpoint in his advocacy of the inherent and divinely ordained rationale within nature as the ultimate source for our standards in art as in life. It is therefore appropriate that the first book in *On Painting*, 'which is entirely mathematical, shows how this noble and beautiful art arises from roots within nature

herself'.[6] By the time he wrote his treatise on architecture, over twenty years later, he was able to express his conviction in the form of a precise definition of beauty:

Beauty is a form of sympathy and consonance of the parts within a body, according to definite number, outline and position, as dictated by *concinnitas*, the absolute and fundamental rule of Nature.[7]

Concinnitas, 'the spouse of the soul and of reason', arose when the three visual properties – number, outline (or shape) and position (or location) – manifested an indissoluble harmony or proportional correspondence in the parts and in the whole, 'so that nothing may be added, taken away or altered, but for the worse'.[8] As he explained when discussing the characteristics of shape:

The outline is a certain correspondence between the lines that define the dimensions; one dimension being length, another breadth, and the third height. The method of defining the outline is best taken from the objects which Nature offers herself to our inspection and admiration . . . I affirm again with Protagoras: it is absolutely certain that Nature is wholly consistent. That is how things stand.[9]

Each of nature's creations is perfectly fitted to its station in life and exhibits a complete propriety of form and function. The concept of 'fittingness' in nature provides the rationale for his artistic doctrine of decorum, to the effect that everything should be internally consistent, appropriate and well ordered in the whole and in the parts of every work of art and building. This rule, like all others, reflected God's intention throughout nature, but such rules could only become manifest in the material world through the existence of the human observer or judge:

The Stoics taught that man was by nature constituted the observer and manager of things. Chrysippus thought that everything on earth was born only to serve man, while man was meant to preserve the friendship and society of man. Protagoras, another ancient philosopher, seems to some interpreters to have said essentially the same thing, when he declared that man is the mean and measure of all things.[10]

A perfect bridge between nature and our human powers of observation and judgement is provided by those arts that are 'born of Chance and Observation, fostered by Use and Experiment, and matured by Knowledge and Reason'.[11] His various speculations about the origins of the figurative arts all rely upon an observer's alert perception of images made by chance in nature, to which intellectual principles are increasingly applied as artists strive towards the goal of rational imitation. His account of the discovery of sculpture in *De Statua* is typical:

I believe that the arts of those who attempt to create images and likenesses from bodies produced by Nature, originated in the following way. They probably occasionally observed in a tree-trunk or clod of earth and other similar inanimate objects certain outlines in which, with slight alterations, something very similar to the real faces of Nature was represented . . . So by correcting and refining the line and surfaces as the particular object required, they achieved their intention and at the same time experienced pleasure in doing so. Not surprisingly man's studies in creating likenesses eventually arrived at the stage where, even when they found no assistance of half-formed images in the material to hand, they were still able to make the likenesses they wished . . . If they sought this objectively through correct and known methods, I believe they would make fewer mistakes and gain complete approval for their works.[12]

The striving of artists to reveal the *concinnitas* innate in nature was not devoted to the isolated end of beauty for its own sake. Beauty was an integral part of the philosophical, moral, political and social order that man should endeavour to realize on earth – not that this realization was readily apparent to Alberti in the society he could see around him. Man's many undesirable propensities and the ravages of *fortuna* posed continual threats to the desired condition. *Momus*, his Latin prose satire cast in the guise of an allegorical fable, makes just this point. Momus is the pestiferous son of Night and Sleep, who, as his 'gift' to the world, supplies plagues of insects. Having been expelled from the heavens, this dubious character enjoys every success in the corrupt society of men. Faced with the ensuing chaos, Jove dithers uncertainly about the best way to establish a new world to replace the old, but he

receives no help from the philosophers, who bumble around inconsequentially. A beacon of hope is provided by a magnificent piece of architecture, a huge Colosseum-like theatre, which signals the way to realize visual and social harmony in the cosmos. Eventually order is established in the original world with the help of Gelastus, a philosopher who assumes a noticeably Albertian outlook.

In a comparable if less sustained way, architecture also appears as a metaphor for social order in one of his tales or *Apologhi*. A fable concerning an ancient temple is used to show how 'arrogance and ostentation always lead to ruin'.[13] The lower stones in the temple, which have long played a valued role in supporting the whole, begin to question their lot and to envy their more elevated colleagues who bear lesser burdens. The result of the lower masonry withdrawing its services is the collapse of the whole edifice. The social moral is that 'prudent men should not despise the position which fate has assigned to them'. For Alberti, the instituting of a well-regulated society was not to be accomplished through extreme measures and certainly not by a revolutionary disruption of social strata.

The whole of *De Pictura* and particularly the passages in praise of painting and of painters in the opening paragraphs of Books II and III demonstrate that painting need yield nothing to architecture or to any of the other arts in man's endeavour to reconstitute the order of nature. Having rhetorically asked the question, 'is it not true that painting is the mistress of all the arts and their principle and ornament', he concludes that 'hardly any art, except the very meanest, can be found that does not somehow pertain to painting. So I would venture to suggest that whatever beauty there is in things has been derived from painting.'[14]

Entirely comparable claims for the sovereign power of painting were made later in the century by Leonardo da Vinci, and coming from his mouth they do not sound surprising. By contrast, Alberti's claims were wholly exceptional for a pioneer humanist in the early Renaissance. His personal emphasis upon visual matters is partly a consequence of his individual talent and taste – he indicates

for example that he had delighted in creating his own 'miracles of painting' even before his residence in Florence in the 1430s – and is in part a reflection of his studies in medieval optical science. The theories of geometrical vision developed by such writers as the Islamic philosopher Alhazen, the Franciscans Roger Bacon and John Pecham, and Witelo from Poland, seemed to provide a perfect illustration of the way in which God's rational design insinuated itself throughout nature. And we should remember that the immaterial splendour of light could readily be interpreted as the most direct manifestation of divine grace in the material world. This elevated science was represented in Padua during Alberti's early years by Biagio Pelecani. Although *On Painting* is not the place for elaborate expositions of ophthalmology and optics, his references to those 'philosophers' who were expert in such matters of the eye and light clearly show his admiration for their science.

The eye had been revered in the Aristotelian tradition as the chief of the sensory organs. As Alberti himself wrote, 'the eye is more powerful than anything, more swift than anything, more worthy than anything'.[15] He adopted a radiant, winged eye as his personal emblem, most conspicuously on the bronze portrait plaque (probably a self-portrait) in the National Gallery, Washington. Alberti is depicted in profile in the *all'antica* manner of a medal, proudly displaying his leonine features and cropped mane of hair. His 'auxiliary' name, Leon (or Leo or Leone), had been adopted for its suitable allusions to the lion's fabled courage and magnanimity, and perhaps also in deference to the legend that a lion's eye was of such power that it did not decay with the death of its owner. In the light of the way in which he allied an interest in vision with his philosophical, literary, artistic and social concerns, he may fairly be regarded as the ideal person to write the first treatise on the principles of painting. Although *On Painting* was written comparatively early in his career, when he was little more than thirty years old, it is a mature expression of the characteristically Albertian attitudes we can discern throughout his writings.

On Painting builds systematically from first visual principles. He begins in Book I, rather as if embarking upon a treatise on Euclidian geometry, with basic definitions of the geometrical properties through which the forms of bodies can be analysed: point, line, surface (or plane), edge, angle, flatness, convexity and concavity. He is, however, concerned at the outset to emphasize that he is not dealing with the immaterial abstractions of pure mathematics but with the visual description of the material world. He relies upon the standard differentiation between such geometrical conceptions as point, line and surface, which have no physical presence since they lack one or more of the three dimensions necessary for tangible existence, and their equivalents in the kind of substantial reality we can perceive through our senses. Alberti's 'point' is therefore a real 'sign' or mark on a physical surface. As he says in his brief essay 'On Points and Lines Among Painters', 'from our definition a point is a sign because the painter perceives it as if it were rather like something between a mathematical point and a quantity that can be classified by number, as perhaps atoms can be'.[16] Adapting a proverbial and somewhat strange expression from Cicero, he emphasizes in *On Painting* that he is speaking in terms of 'Minerva' ('the coarser wisdom of our senses'), or 'la più grassa Minerva' as he describes it in the Italian text.[17] In keeping with his emphasis upon sensate knowledge, he avails himself of a series of material metaphors and similes to describe the geometrical properties of bodies. Edge is described as an *ora* (brim) or *fimbria* (fringe or hem), conveying the sense of an 'outline' as actually used by the draughtsmen. A circle is like a 'crown', and the nature of concave and compound surfaces are respectively explained by reference to the inner surfaces of eggshells and outer surfaces of columns.

Such material bodies can only be fully perceived through light, as the earlier students of optics had stressed, and Alberti explains the process of vision in terms of a highly simplified version of medieval optical science. The basis of our perception of the relative sizes of objects is the visual pyramid or cone, comprising light rays converging to or diverging from a notional vertex within the eye (Fig. 1). The 'centric ray', which passes along our

visual axis, plays a key role in the 'certification' of sight, as it had done for 'the philosophers', while the 'extrinsic' and 'median' rays convey information about outline and surface respectively. Unlike such medieval predecessors as Pecham, whose *Perspectiva communis* had become the standard textbook, he does not deal with the complexities of what happens to the light rays within the eye, nor is he concerned to debate the old and contentious question as to whether the rays only entered the eye or were emitted as 'seeing beams'. He also declines to commit himself on the origins of colours, although he is clearly aware of the competing theories within the Aristotelian tradition that the basic or primary colours either arise as a result of mixtures of lightness and darkness in different proportions or are generated by the respective properties of the four elements. His sole concern in *On Painting* is to establish the rudiments of optical geometry external to the eye, and their consequences for the painter.

The picture is conceived as equivalent to the intersection of the pyramid by a plane which is perpendicular to the axis of sight (or the 'centric ray'). The distance of the intersection from our eye will affect the actual size of the picture, but not the *relative proportions* of the objects in the visual array as recorded on the picture plane. It is through these relative proportions that the sizes and distances of objects become apparent by reference to an internal measure or scale of known dimensions. In line with Protagoras and the medieval opticians, Alberti regards the figure of man as the most appropriate standard of reference.

It is this human mean or measure that he uses when he begins to provide directions for the construction of perspectival space, though he nowhere explains why the properties of the pyramid result in the reciprocal geometry of his pictorial construction. He merely implies that he could undertake the proof if required to do so: 'I used to demonstrate these things at greater length to my friends with some geometrical explanations.'[18] His basic construction is outlined in a step-by-step manner and results in a foreshortened grid or tiled pavement. The vanishing point – his 'centric point' – lies on the horizon at the head-height of his modular

man. Alberti apparently supplied no illustrations, and modern diagrams of his procedures, such as those provided in this edition (Figs. 8 and 10–11), have tended to place the 'centric point' in the middle of the horizon and half-way up the picture. This gives the impression of visual inflexibility, but he emphasizes that he is doing no more than introducing the aspiring painter to the 'rudiments' of the art; that is to say, to the principles upon which the artist can build his practice, exercising his inventiveness as appropriate to the particular task in hand. He is not telling us how the space should be arranged in every painting.

The advantage of laying in the tiled pavement as a first step is that it provides a series of modular measures into and across the space of the picture to which any vertical and horizontal elements of known dimensions can be related. In Book II, under the aegis of 'circumscription', Alberti describes how walls can be constructed according to their due scale on the ground plan for the foreshortened grid (Fig. 13) and how a circle can be transposed on to the pavement in the painting by noting the equivalent points at which the outline of an unforeshortened circle would intersect an unforeshortened grid (Fig. 14).

Book II opens with an extended digression, addressed to 'the young', on the *virtù* of painting, using a cluster of citations from ancient authors to emphasize its 'divine power', moral worth and the high social status of its practitioners. The main purpose of the second book is to 'instruct the painter how he can present with his hand what he has understood in his mind'.[19] The art of representation is divided into three parts, 'circumscription', 'composition' and 'reception of light' – in a sequence that parallels the historical development of art from its primeval origins. 'Circumscription' deals with the basic draughtsmanship through which bodies are represented in terms of contours and outlines, using the foreshortened grid as the measure for all spatial relations. The concept of 'composition' is especially important, and represents one of Alberti's most original contributions to art theory. 'Composition' is the way in which 'surfaces', 'members' and 'bodies' can be brought systematically together in decorous harmony. It provides the

means by which variety and order can be reconciled, much as the rules of Latin sentence construction permitted the Roman authors he admired, above all Cicero and Quintilian, to express their meaning with measured power. Every surface, member and body must be organized so as to be in keeping with the whole, and the whole must be edifying at the highest level. Not surprisingly a transvestite Mars or rustic Helen would attract derision, but the requirements of decorous composition go further than such general prescriptions. Every smallest part of the human figure should be expressive of its physical nature, social status and mental state. Thus a dead figure should declare its deadness right down to its very fingertips, as in 'a *historia* in Rome [a marble relief on an ancient sarcophagus] in which the dead Meleager is carried away'.[20] The *historia* (a term that resists precise translation) was the supreme achievement for the painter, embodying all the moral worth which could be realized through his command of beauty, expression and significance. His one modern example of a *historia* is Giotto's lost mosaic in old St Peter's depicting Christ and St Peter walking on the water, in which each disciple exhibits 'such clear signs of agitation on his face and entire body that the individual emotions are discernible in every one of them'.[21]

The expressions, gestures and motions of the figures should be potent and declamatory, like those of an orator, but they should not be violent or extreme. An indecorous tumult or cacophony is not to be admired, and he cites with approval 'Varro's dictum' to the effect that 'no more than nine guests' should be invited to dinner 'to avoid disorder'.[22] He also knows the virtues of understatement, citing as an example the way in which Timanthes had veiled the head of Iphigenia's grief-stricken father, leaving 'more for the onlooker to imagine about his grief than he could see with the eye'.[23] The need for temperate decorum is as great in the process through which the *historia* is realized as in the final product itself. Indeed, the latter is predicated on the former. 'An extravagant artistic talent', which begins painting in a furious transport of creative enthusiasm, will give rise to works that are devoid of dignity and deficient in finish.[24]

Alberti's treatment of the 'reception of light' is no less original than his discussion of 'composition'. He clearly identifies the roles of black and white (and by implication shades of grey) as modifiers of coloured pigments to give the effect of modelling in light and shade, and differentiates their visual properties from those of the individual colours – differentiating between what we call tone and hue. The individual hues are the 'genera' of colours, while black and white generate the 'species'. Although he is far from insensitive to the charm of colours individually and in cunning combinations, he places the highest value on the use of black and white to achieve the illusion of solid forms. Even here, however, moderation is the watchword. Excessive use of white and black is harsh and disagreeable, leaving the painter with nothing in reserve for the few really brilliant highlights such as those on Dido's quiver of gold. He is insistent that it is part of the merit of painting that gold can be evoked through the artist's skill in manipulating hue and tone, rather than by the application of actual gold to the surface of the painting. The glitter of gold and jangle of gaudy colours will only appeal to the eyes of the ignorant.

Having laid down a demanding agenda for the making of art in his first two books, passing from the 'roots in nature' to the actual principles and methods of representation, Alberti proceeds in Book III to review some of the personal requirements for the painter who wishes to live up to the ideals of his vocation. The stipulations are both moral and artistic: 'I would have this painter first of all to be a good man and well versed in the visual arts.'[25] A knowledge of geometry and an acquaintance with literary matters (and with literary men) go hand-in-hand in providing form and content for the painter's inventions. The capacity to devise a worthy 'invention' – that is to say, the conception of a compelling subject – is greatly prized in its own right, as for example in Apelles's devising of his famous *historia* of 'Calumny', known to us from Lucian's description. However, the painter should not believe on this account that he should resort only to his own imagination, believing it to be self-sufficient. Rather he must have continual recourse to nature as his ultimate guide.

Nature is also responsible for the way in which different paint-
ers best exhibit their gifts in different branches of painting –
some excelling in male and others in female figures, some in
ships, some in animals and so on – but any painter who aspires
to achieve true excellence should not limit his ambitions to the
field in which he feels most naturally at home: 'it is a tremend-
ous gift, and not one granted to any of the ancients, for a man
to be, I will not say outstanding, but even moderately learned
in everything.'[26] No painter should find the path towards excel-
lence barred, providing he equips himself properly, correctly
reads the signposts in the natural world, and undertakes his ardu-
ous journey with sufficient resolution: 'the gifts of Nature
should be cultivated and increased by industry, study and prac-
tice, and nothing that pertains to glory ought to be overlooked
and neglected by us'.[27]

On Painting as a whole is designed to inculcate in the painter,
particularly one who is still young, awareness of the systematic
means and elevated ends of painting. The prize for the cultivation
of genuine virtù in art is the praise of those who are knowledgeable
and a lasting fame that resists the vagaries of fortuna. Thus
equipped, Alberti is confident that the painter can play a significant
role in the realization of human potential in those pursuits that
possess tangible and enduring values. The message is an archetypal
statement of Renaissance optimism.

ANCIENT AND MODERN

Alberti, like other leading figures in the arts of the Renaissance,
was simultaneously a reviver of ancient ideas and a creative voice
in the establishment of a new age. His production of his treatise
On Painting in two versions, one in Latin and the other in Italian,
is symptomatic of this double ambition. An inscription on his
copy of Cicero's Brutus testifies that 'on the day of Friday at 20.45
hours on 26 August 1435 I completed the work De Pictura in
Florence'. The manuscript of the Italian version in the Biblioteca
Nazionale in Florence is inscribed, 'finished praise be to God on

the 7th day of the month of July 1436'.[28] The advantage of making his treatise available in two languages was not only that it became accessible to different kinds of readership – groups of humanist scholars and practitioners of the visual arts – but that it satisfied his desire to establish the merits of a refined vernacular alongside Latin.

A substantial amount of his literary production was in Latin, and many of Alberti's works directly emulated his favourite Roman authors. His revival of ancient genres was not dry and humourless. He was particularly drawn to witty and satirical tales, composing his own pithy *Intercoenales* (what we would call 'after-dinner stories') in the manner of Lucian, and dedicating a collection of them to Paolo Toscanelli, a doctor who was a leading student of mathematics, astronomy and optics. His humanist friend in Ferrara, Guarino da Verona, dedicated his translation of Lucian's *Musca* (*The Fly*) to Alberti, who on his own account composed an ironic work on the same theme which he sent to Landino. In a similar vein Alberti wrote a ringing eulogy of his faithful dog. His encomium of canine virtue is not only a virtuoso display of knowledge of the ancients, but also mocks the formulas and pomposities that can all too easily dominate humanist writing. His dog is said to have been 'born of most noble ancestors . . . and amongst his ancient ancestors were an infinite number of famous persons', including 'ancient and learned persons of Egypt'.[29] This paragon of the doggy race displayed a *virtù* worthy of the ancients: 'in every moment of his life he was involved in praiseworthy deeds'.

For a number of the leading Tuscan humanists, the qualities of their own vernacular tongue could, if subjected to the rule of grammatical law, achieve a status equal to that of Latin as a literary vehicle. In *Della Famiglia* Alberti writes,

I fully admit that the ancient Latin language was rich and beautiful, but I see no reason why our present-day Tuscan is so contemptible that anything written in it, however excellent, should fail to satisfy us . . . As to the great authority among all nations which my critics attribute to the

ancient language, this authority exists simply because many learned men
have written in it. Our tongue will have no less power as soon as learned
men decide to refine and polish it by zealous and arduous labours.[30]

Alberti played his own part in these 'zealous labours', not only by
composing exemplary works in the vernacular such as *Della
Famiglia*, and by organizing a public competition in Florence for
Italian poetry in 1441, but also by devising the first systematic
book of grammar for Tuscan, his *Regule lingue florentine* (otherwise
known as the *Grammatichetta Vaticana*). Cristoforo Landino, him-
self a great student of the vernacular as a commentator on Dante,
warmly acknowledged Alberti's contribution: 'notice with what
industry he has contrived to transfer to our tongue all the elo-
quence, composition and nobility which is found in Latin.'[31]

On Painting, whether in its Latin or Italian versions, perfectly
embodies the twin aspirations of retrospective emulation and
progressive innovation. The form of *On Painting* – its organization
into three books and its systematic progression through rudiments,
practice and ends – is deeply influenced by Roman treatises on
rhetoric, most especially Quintilian's *Institutio oratoria*. And, like
any composition by a good humanist, it makes regular reference
to classical precedent, whether by direct quotation and citation,
particularly from the section on ancient artists in Pliny's *Natural
History*, or by the kind of allusion his learned audience would
have been ready to appreciate. The polished version of the Latin
text was dedicated about 1440 to Gianfrancesco Gonzaga, Marquis
of Mantua, and, although we may doubt the marquis's own
enthusiasm for reading learned treatises in Latin, Alberti was
shrewdly placing his work in an environment where it would be
appreciated. In Mantua Gianfrancesco sponsored the influential
humanist school, La Giocosa, run by Vittorino da Feltre, who had
previously succeeded Alberti's teacher, Barzizza, in the chair of
rhetoric at Padua. At this school such future patrons as Federigo
da Montefeltro of Urbino and Lodovico Gonzaga were to receive
their grounding in the arts and philosophies of the ancient and
modern worlds. In the dedication of *On Painting* Alberti's pitch is

clear, praising the *virtù* of the marquis in arms and letters and expressing the hope that the contents of his treatise 'may prove worthy by their art of the ears of learned men, and may also please scholars by the novelty of their subject ... And I shall believe my work has not displeased you, if you decide to enrol me as a devoted member among your servants [*inter familiares*].'[32]

In judging the intended audience and function of *On Painting*, this original context of humanist patronage has to be borne in mind. There are numerous indications in the text and in the overall organization of the treatise that it is aimed at the 'young painter', but it is not an instructional book of the kind intended for the average studio apprentice. Rather, Alberti exploits the vehicle of a pedagogic treatise, in the manner of Quintilian's *Institutio oratoria*, to expound the principles of the discipline in such a way as to impress fellow students of the liberal arts, particularly the young and those entrusted with the education of the young. His success may be judged by the survival of twenty or so manuscripts of the Latin text. Only three manuscripts of the Italian version are known. Although we have to allow for the possibility that the survival rate of the Italian text in artistic circles may have been less than that of the Latin manuscripts in libraries, the relative proportions do appear to reflect the original aim of the treatise.

The Italian text is not a straight translation. There are a number of passages in the Latin that have been omitted in the Italian, as denoted in this edition by the sections printed in italics. The omitted passages include some of the more 'scientific' asides which allude to traditional optics, and some of the learned references, such as 'Varro's dictum' about the number of guests at a banquet. Very occasionally the Italian helps clarify the meaning of the Latin, but it is generally the case that the original text conveys Alberti's sense with more precision. Indeed, the steps of the perspective construction cannot be unambiguously understood from the Italian text alone. The single most valuable aspect of the vernacular translation for the modern reader is the letter dedicating it to Filippo Brunelleschi, which contains a classic statement of

the 'rebirth' of the arts and bears vivid witness to the impact of the great Florentine pioneers of the Renaissance style in the visual arts. In his dedication of *Della Pittura*, Alberti was not addressing a typical 'artist'. Brunelleschi, as the son of a notary, was probably given a good education, and may already have expressed his admiration for *De Pictura* in its original Latin form. The other contemporary artists eulogized by Alberti in the Preface – 'our great friend the sculptor Donatello', Lorenzo Ghiberti, Luca della Robbia and Masaccio – may not all have been well-read to the same degree, but they belonged to the elite band that was reforming Tuscan art in the light of Roman ideals. Ghiberti was himself to write ingenious *Commentaries* on the figurative arts later in his career.

The achievement of Brunelleschi which is singled out for praise is his construction of the huge dome of Florence Cathedral, rather than his invention of perspective. Alberti's failure to mention Brunelleschi in connection with perspective should not be taken to mean that he was attempting to claim all the glory for himself, or even that Brunelleschi's early biographer was wrong to credit his hero with its invention. Rather, it most likely reflects the fact that Brunelleschi's achievement did not provide a precise precedent for Alberti's system. Brunelleschi had accomplished, probably before 1413, the perspectival projection of two of Florence's most prominent buildings, the Baptistery and the Palazzo de' Signori (now the Palazzo Vecchio), in two demonstration panels which no longer survive. His procedures, whatever their actual nature, worked from known structures rather than pre-establishing an abstract space into which forms could be placed. During the mid-1420s, Donatello in relief sculpture and Masaccio in painting had adapted Brunelleschi's invention for the a priori laying down of imaginary settings in mathematical perspective. Masaccio's famous *Trinity* in S. Maria Novella provides the most developed example. Alberti's innovation was to extract from the most advanced pictorial practice the 'rudiments' of the construction – the underlying rules or general case – so that its principles might be readily communicated.

Alberti was obviously a perceptive observer of artistic practice. His rules on narrative and characterization suggest a close study of Donatello, Ghiberti and Masaccio, and we have already noted his praise of Giotto's *historia* in Rome. He was also, by his own testimony, a dilettante artist in his own right, although no surviving painting can be convincingly attributed to him.[33] *On Painting* is not at all concerned with the material aspects of the craft of painting, unlike Cennino Cennini's *Il Libro dell'arte*, which had been written around the turn of the century and contained careful instructions on the preparation of surfaces, the handling of pigments, etc. However, there are numerous signs that Alberti was speaking as someone who had striven on his own account to make paintings. He recommended an invention of his own as practical aid for the draughtsman who wishes to imitate nature, namely the 'veil' or 'intersection', which consists of a translucent cloth divided into squares. The object to be copied is observed through the 'veil' from a fixed point and its outlines transposed on to a drawing surface that has been divided into corresponding squares. He also provides other practical hints, noting how the painter moves his viewpoint back and forth to find the ideal position for representing a particular form, how looking at objects through half-closed eyes will help consolidate the masses of light and shadow, and how studying a painting in a mirror will show it in a new way to reveal its faults. His occasional remarks on actual effects in the seen world, such as his comments on different types of draperies and his observations of green reflections in the faces of those who walk through meadows, show a 'painter's eye' at work.

Alberti was fully conscious of the fresh and novel qualities of *On Painting* as a whole and in its details. No doubt he hoped that it would be influential. One aspect of its influence has already been suggested when we noted the humanist audience for the Latin text. A prospective patron of the arts who had read *On Painting* would be more likely to act as a knowing patron for an artist such as Piero della Francesca than one who was ignorant of the intellectual basis of painting. The more direct aspect of its

influence would be on the actual practice of the figurative arts. There are clear signs in the practice of Florentine art in the 1430s and 1440s of the impact of Alberti's ideas. Ghiberti was probably one of the first to respond, during the course of his design of the perspectival bronze reliefs on his second set of doors for the Florentine Baptistery. Fra Angelico and Domenico Veneziano both adopted aspects of Alberti's prescriptions for space and narrative. Fra Angelico's frescos in the Vatican chapel for Nicholas V, the humanist Pope who was the recipient of Alberti's *De Re aedificatoria*, are an almost perfect embodiment of Albertian principles. And Piero della Francesca understood Alberti's message to such effect that he was able to extend Alberti's intellectual aspirations both in pictorial practice and through his own theory of perspective in *De Prospectiva pingendi*. Alberti's detailed analysis of classical subjects, such as the 'Three Graces' or the 'Death of Iphigenia', and his recommendation of Apelles's 'Calumny' as an exemplary *historia*, seem only to have borne full fruit later in the century in the practice of Mantegna and Botticelli, both of whom were employed by patrons who were fully cognizant of Alberti's significance.

Amongst later generations of Renaissance painters, no one paid closer heed to Alberti than Leonardo da Vinci, whose own extensive injunctions on the theory and practice of painting contain repeated echoes of his predecessor's ideas. Although Leonardo's remorseless insistence on scientific naturalism made far more extensive demands on the painter's knowledge of natural law than Alberti's relatively simple prescriptions, there is no radical departure from the tenor of Alberti's message.

Following the first printed editions – the Latin text in 1540 in Basel, and Lodovico Domenichi's Italian translation from the Latin in Venice in 1547[34] – *On Painting* was well placed to play an influential role in the establishing of principles in the earliest academies of art. The decade that saw Giorgio Vasari's foundation of the Florentine Accademia del Disegno in 1563 also witnessed editions of Italian translations in Florence and Venice.[35] Vasari's own major work on the visual arts, his *Lives* of the artists, is not

primarily theoretical in intent, but the underlying precepts often have an Albertian flavour. The newly emergent Royal Academy in Paris was the setting in the next century for Dufresne's first French edition in 1651, while the first English translation by Leoni in the eighteenth century appeared at a time when the English artists were belatedly acquiring academic aspirations.[36] The European wave of Neoclassicism in the later part of the eighteenth century was accompanied by a series of editions in Italy and Spain, as artists strove to recapture the classical purity of ancient art, both directly and via the Renaissance authorities.[37] This close association with the academic institutionalization of art worked against the reputation of Alberti's treatise when the academies fell into progressive disrepute during the nineteenth and twentieth centuries. But read with an appreciation of its original setting, On Painting is far from being a dreary work of academic orthodoxy. Rather it is a vigorous and creative assertion of ideas that were reforming the theory, practice and social implications of painting.

The nineteenth century saw the first scholarly editions of Alberti's treatise as a historical text. In 1847 Bonucci published Alberti's own Italian version (rather than Italian translations by others from the Latin edition) as part of his Florentine edition of Alberti's works in Italian.[38] Subsequently, for obvious reasons of modern convenience, it was this Italian text that became the standard point of reference. It was republished and translated into German by Janitschek in 1877, and a superior edition published by Mallé in Florence in 1950.[39] It was this edition that provided the basis for John Spencer's new English translation in 1956, revised in 1966.[40] Spencer's translation, widely available, has continued to serve the needs of students and the general reader, in spite of the appearance in 1972 of Cecil Grayson's edition and translation of the Latin text.[41] Not only is the Latin text superior to the Italian, for the reasons already indicated, but Grayson's translation is to be trusted far more than any other. Grayson was Serena Professor of Italian Studies at Oxford, and is the greatest scholar and editor of Alberti's literary works in this century. In establishing the Latin text on which it is based Grayson primarily used six manuscripts

of the version presented to Gianfrancesco Gonzaga, but he also consulted other manuscripts as well as the first printed edition. He subsequently produced (1973) a critical text of the vernacular *Della Pittura* for his edition of Alberti's *Opere volgari*, with the Italian and Latin versions on facing pages.[42] His 1972 text of *On Painting*, issued in a volume that also contained a Latin text and translation of *De Statua*, has long since been out of print and is not widely available outside academic libraries. The present publication of his translation is intended to rectify this and to make publicly available the best possible version of Alberti's text for the modern reader of English.

THE PRESENT EDITION

Grayson's translation has been left largely untouched. Where alternative readings initially seemed to be preferable, it was generally found that Grayson's solution represented the best way of rendering Alberti's sense for the modern reader without indulging in unnecessary anachronisms. I did, for instance, consider altering his translation of *fimbria* (literally 'fringe' or 'hem') from 'outline', which seemed to carry too specific a modern meaning, to a more neutral term such as 'edge'. On reflection, 'outline' did seem to convey Alberti's sense of a contour drawn with an actual line by the draughtsman. A number of Alberti's terms carried specific and loaded meanings in their humanist context, and any straight translation is likely to be inadequate. The term *ingenium* is a case in point. There is a temptation to translate it as 'genius', which Grayson does on occasion, but its Renaissance meaning was closer to 'talent', with connotations of 'mind', intellect', 'ability' and 'merit', which are also terms used by Grayson to render Alberti's *ingenium*. I considered altering the rendering to 'talent' throughout, but this would result in a stilted sense in some passages, and it is preferable to retain Grayson's more flexible response. A few minor adjustments have been made. I am grateful for Professor Grayson's advice on a number of points in the introduction and translation.

· 25 ·

The dedicatory letter to Brunelleschi has also been included here in Grayson's translation, although it preceded the Italian rather than the Latin version. Sections that were omitted by Alberti from the Italian text are here printed in italics, to give the reader an indication of the small but significant contractions made by the author when he presented his work to a different audience. The paragraph numbers are those supplied by Grayson. The notes and diagrams are provided by the present editor, drawing heavily upon Grayson for references to the classical sources cited by Alberti. The diagrams are the most complete in any edition to date, and I believe they are the first to be placed at appropriate points in the actual text.

Grayson's original Introduction can be read with profit by those with some knowledge of Alberti's career and the cultural background, but the present Introduction is designed to serve the broader purpose of setting *On Painting* in the context of the author's life and philosophy, as well as highlighting some of the characteristics of the treatise itself. The greater part of Alberti's literary legacy remains little known and under-explored. If the present publication not only brings *On Painting* to the notice of a wider public but also stimulates a productive curiosity about his other writings, it will have served a double purpose.

Notes to the Introduction

All references to *On Painting* are by paragraph numbers unless otherwise noted.

1. *Leon Baptistae Alberti de re aedificatoria incipit* . . ., Florence, 1486; trs. J. Rykwert, N. Leach and R. Tavernor, *On the Art of Building in Ten Books*, Cambridge (Mass.) and London, 1988, p. 1 (all subsequent refs. to this trs. as *De Re aed.*).
2. *I Libri della Famiglia*, trs. R. N. Watkins, *The Family in Renaissance Florence*, Columbia (South Carolina), 1969, p. 89 (all subsequent refs. to this trs. as *Della Famiglia*).
3. Ibid., p. 145.
4. *Della Pittura*, Dedicatory letter, see below, p. 34.
5. *De Re aed.*, p. 3.
6. *Della Pittura*, Dedicatory letter, see below, p. 35.
7. *De Re aed.*, p. 303.
8. Ibid., p. 156.
9. Ibid., pp. 304–5.
10. *Della Famiglia*, pp. 133–4.
11. *De Re aed.*, p. 157.
12. *De Statua*, ed. and trs. C. Grayson in L. B. Alberti, *'On Painting' and 'On Sculpture'*, London, 1972, pp. 120–21.
13. 'Templum' in *Apologhi ed elogi*, ed. R. Contarino, Genoa, 1984, pp. 84–5 and 106–9.
14. *De Pictura*, 26.
15. *Anuli* in *Leonis Baptistae Alberti opera inedita*, ed. G. Mancini, Florence, 1890, p. 228.
16. *De Punctis et lineis apud pictores*, in *Opera inedita*, ed. Mancini, p. 66.
17. *De Pictura*, 1: 'pinguiore idcirco, ut aiunt, Minerva scribendo'; and *Della Pittura*: 'per questo useremo quanto dicono la più grassa minerva'. Compare

Cicero, *De Amicitia*, V, 16: 'Agamus igitur pingui, ut aiunt Minerva' ('Let us then proceed, as they say, with our own coarse senses').

18. *De Pictura*, 23.

19. Ibid., 24.

20. Ibid., 37.

21. Ibid., 42, known in various drawn copies and a somewhat unreliable engraving by Nicolas Beatrizet. See W. Oakeshott, *The Mosaics of Rome*, London, 1967, pp. 328–32.

22. Loc. cit. Compare Aulus Gellius, *Noctium atticarum*, XIII, xi, 2–3.

23. *De pictura*, 42.

24. Ibid., 44 and 61.

25. Ibid., 52.

26. Ibid., 60.

27. Loc. cit.

28. Cicero's *Brutus* in the Biblioteca Marciana, Venice, Cod. lat.67.cl.xi, last folio; and *Della Pittura* in the Biblioteca Nazionale, Florence, MS II. IV.38, f.163v. These inscriptions probably, but not certainly, refer to the completion of the Latin and Italian versions. See G. Mancini, *Vita di L. B. Alberti*, 2nd ed., Rome, 1911, p. 128 n.1, and C. Grayson, 'Studi su Leon Battista Alberti, II. Appunti sul testo della *Pittura*', *Rinascimento*, IV, 1953, pp. 54–62.

29. 'Canis' in *Apologhi ed elogi, op. cit.*, pp. 142 and 162.

30. *Della Famiglia*, p. 153.

31. Mancini, *Vita*, p. 441.

32. *De Pictura*, below, p. 36.

33. The most recent attempt to attribute a painting to Alberti is by J. Beck, 'Leon Battista Alberti and the "Night Sky" at San Lorenzo', *Artibus et Historiae*, X, 1989, pp. 9–36.

34. *De Pictura praestantissima et numquam satis laudata arte libri tres absolutissimi Leonis Baptistae Albertis*, Basel, 1540; and *La Pittura*, trs. L. Domenichi, Venice, 1547.

35. *La Pittura*, trs. Domenichi, Florence, 1568; and *Della Pittura*, ed. and trs. C. Bartoli, in *Opuscoli morali di L. B. Alberti*, Venice, 1568.

36. *Trattato della Pittura de Leonardo da Vinci . . . si sono agiunti i tre libri della pittura e il trattato della Statua di Leon Battista Alberti*, ed. R. Dufresne, Paris, 1651; and L. B. Alberti, *The Architecture . . . in Ten Books. Of Painting in Three Books. And of Statuary in One Book*, trs. G. Leoni (from Bartoli's Italian trs. of *De pictura*), London, 1726.

37. London ed. of 1755 (Leoni trs. of Dufresne); two Bologna eds. of 1782 (Bartoli text and Dufresne text); Madrid ed. of 1784 (trs. D. Diego Antonio Rejon de Silva); Bologna ed. of 1786 (Dufresne text); Milan eds. in 1803 and 1804 (Bartoli text);Perugia ed. in 1804 (Bartoli text).

38. *Opere volgari di Leon Battista Alberti*, ed. A. Bonucci, 5 vols., Florence, 1843–9.

39. *Leon Battista Albertis Kleinere Kunsttheoretische Schriften* (Italian, with German

trs.) ed. H. Janitschek in *Quellenschriften für Kunstgeschichte*, XI Vienna, 1877; and *Della Pittura*, ed. L. Mallè, Florence, 1950.

40. L. B. Alberti, *On Painting*, trs. with intro. and notes by J. R. Spencer, New Haven, 1956, and rev. ed., New Haven and London, 1966.

41. L. B. Alberti, *'On Painting' and 'On Sculpture'*, ed. and trs. C. Grayson, with intro. and notes, London, 1972.

42. *Opere volgari*, ed. Grayson, Vol. III, Bari, 1973.

Further Reading

SELECTED WRITINGS BY ALBERTI

Opera inedita, ed. G. Mancini, Florence, 1890

Opere volgari, ed. C. Grayson, 3 vols., Bari, 1960, 1966 and 1973

Della Pittura, ed. L. Mallè, Florence, 1950

La prima grammatica della lingua volgare, ed. C. Grayson, Bologna, 1964

L'Architettura (De Re aedificatoria), ed. and Italian trs. G. Orlandi with intro. and notes by P. Portoghese, 2 vols., Milan, 1966

De Pictura and *De Statua* in L. B. Alberti, *'On Painting' and 'On Sculpture'*, ed. and trs. C. Grayson, London, 1972

Apologi ed elogi, ed. R. Contarino, Genoa, 1984

Momo o del principe, ed. R. Consolo, Genoa, 1986

On Painting, trs. J. R. Spencer, rev. ed., London and New Haven, 1966

The Family in Renaissance Florence, trs. of *Della Famiglia* by R. N. Watkins, Columbia (South Carolina) 1969

Leon Battista Alberti, Dinner Pieces, Binghampton (New York), 1987

On the Art of Building in Ten Books, trs. of *De Re aedificatoria* by J. Rykwert, N. Leach and R. Tavernor, with intro. by J. Rykwert, Cambridge (Mass.) and London, 1988

BIOGRAPHIES AND MONOGRAPHS

For the early *Vita* (anonymous but probably an autobiography), see R. Fubini and A. Menci Gallorini, 'L'autobiografia di L. B. Alberti. Studio e edizione', *Rinascimento*, XII, 1972, pp. 21–78.

G. Mancini, *Vita di Leon Battista Alberti*, Florence, 1882, 2nd ed., Rome, 1911 (reprinted, Rome 1967)

P. H. Michel, *Un Idéal humain au XVe siècle: La Pensée de L. B. Alberti*, Paris, 1930

C. Grayson, 'Alberti, Leon Battista', *Dizionario biografico degli italiani*, vol. I, Rome, 1960, pp. 702–9, and in *Dizionario critica della letteratura italiana*, ed. V. Branca, 2nd ed., Turin, 1986

J. Gadol, *Leon Battista Alberti. Universal Man of the Early Renaissance*, Chicago and London, 1969

F. Borsi, *Leon Battista Alberti*, Oxford, 1977

'Leon Battista Alberti', *Architectural Design*, XLIX, 1979 (A.D. Profiles 21, special issue, ed. J. Rykwet, with contributions by C. Grayson, H. Damish, F. Choay, M. Tafuri, H. Burns, R. Tavernor and J. Rykwert)

M. Jarzombek, *On Leon Battista Alberti*, London, 1989.

A. Grafton, *Leon Battista Alberti. Master Builder of the Italian Renaissance*, London, 2002

LITERATURE ON *DE PICTURA*, OPTICS, PERSPECTIVE, ARCHITECTURE, ETC.

C. Grayson, 'Studi su L. B. Alberti', *Rinascimento*, IV, 1953, pp. 54–62

R. Watkins, 'Alberti's Emblem, the Winged Eye, and his Name, Leo', *Mitteilungen des Kunsthistorischen Instituts in Florenz*, IX, 1960, pp. 256–8

R. Wittkower, *Architectural Principles in the Age of Humanism*, 3rd ed., London, 1962

G. F. Vescovini, *Studi sulla prospettiva medievale*, Turin, 1965

J. R. Spencer, 'Ut rhetorica pictura', *Journal of the Warburg and Courtauld Institutes*, XX, 1966, pp. 26–44

J. White, *The Birth and Rebirth of Pictorial Space*, 2nd ed., London, 1967

C. Grayson, 'The Text of Alberti's *De Pictura*', *Italian Studies*, XXIII, 1968, pp. 71–92

S. Y. Edgerton Jnr., 'Alberti's Colour Theory. A Mediaeval Bottle without Renaissance Wine', *Journal of the Warburg and Courtauld Institutes*, XXII, 1969, pp. 109–34

R. Weiss, *The Renaissance Discovery of Classical Antiquity*, Oxford, 1969

L. H. Heydenreich and W. Lotz, *Architecture in Italy, 1400–1600*, Harmondsworth, 1974

S. Y. Edgerton Jnr., *The Renaissance Rediscovery of Linear Perspective*, New York, 1975

M. Baxandall, *Giotto and the Orators. Humanist observers of painting in Italy and the discovery of pictorial composition*, Oxford, 1971

D. C. Lindberg, *Theories of Vision from Al-Kindi to Kepler*, Chicago, 1976

D. R. E. Wright, 'Alberti's *De pictura*: its Literary Structure and Purpose', *Journal of the Warburg and Courtauld Institutes*, XLVII, 1984, pp. 52–71

P. Hills, *The Light of Early Italian Painting*, New Haven and London, 1987

J. Onians, *Bearers of Meaning. The Classical Orders in Antiquity, the Middle Ages and the Renaissance*, Princeton, 1988.

M. Kemp, *The Science of Art. Optical Themes in Western Art from Brunelleschi to Seurat*, New Haven and London, 1990

C. Smith: *Architecture in the Culture of Early Humanism: Ethics, Aesthetics and Eloquence, 1400–1470* (New York and Oxford, 1992)

ON PAINTING

OTHER THEORISTS ETC.

Cennino Cennini, *Il Libro dell'arte*, trs. D. Y. Thompson, *The Craftsman's Handbook*, New Haven, 1933

Lorenzo Ghiberti, *I Comentarii*, ed. O. Morisani, Naples, 1947

Antonio Manetti(?), *The Life of Brunelleschi*, ed. H. Saalman, trs. C. Engass, London and Pennsylvania, 1970

Leonardo on Painting, ed. M. Kemp, trs. M. Kemp and M. Walker, New Haven and London, 1989

A. Blunt, *Artistic Theory in Italy, 1450–1600*, Oxford, 1940

M. Baxandall, *Painting and Experience in Fifteenth-Century Italy*, Oxford, 1972

M. Kemp, 'From "Mimesis" to "Fantasia": the Quattrocento Vocabulary of Creation, Inspiration and Genius in the Visual Arts', *Viator*, VIII, 1977, p. 347

Italian Art, 1400–1500 ('Sources and Documents'), ed. C. Gilbert, Englewood Cliffs (N.J.), 1980

D. Summers, *The Judgement of Sense*, Cambridge, 1987

F. Ames-Lewis, *The Intellectual Life of the Early Renaissance Artist*, London and New Haven, 2000

ON PAINTING

Dedication of the Italian Text
To Filippo Brunelleschi

I USED both to marvel and to regret that so many excellent and divine arts and sciences, which we know from their works and from historical accounts were possessed in great abundance by the talented men of antiquity, have now disappeared and are almost entirely lost. Painters, sculptors, architects, musicians, geometers, rhetoricians, augurs and suchlike distinguished and remarkable intellects, are very rarely to be found these days, and are of little merit. Consequently I believed what I heard many say that Nature, mistress of all things, had grown old and weary, and was no longer producing intellects any more than giants on a vast and wonderful scale such as she did in what one might call her youthful and more glorious days. But after I came back here to this most beautiful of cities from the long exile in which we Albertis have grown old, I recognized in many, but above all in you, Filippo, and in our great friend the sculptor Donatello and in the others, Nencio, Luca and Masaccio, a genius for every laudable enterprise in no way inferior to any of the ancients who gained fame in these arts.[1] I then realized that the ability to achieve the highest distinction in any meritorious activity lies in our own industry and diligence no less than in the favours of Nature and of the times. I admit that for the ancients, who had many precedents to learn from and to imitate, it was less difficult to master those noble arts which for us today prove arduous; but it follows that our fame should be all the greater if without preceptors and without any model to imitate we discover arts and sciences

hitherto unheard of and unseen. What man, however hard of heart or jealous, would not praise Filippo the architect when he sees here such an enormous construction towering above the skies, vast enough to cover the entire Tuscan population with its shadow, and done without the aid of beams or elaborate wooden supports?[2] Surely a feat of engineering, if I am not mistaken, that people did not believe possible these days and was probably equally unknown and unimaginable among the ancients. But I will speak elsewhere of your praises and the talent of our friend Donatello, and of the others who are dear to me for their virtues. I beg you to go on, as you are doing, finding means whereby your wonderful merit may obtain everlasting fame and renown, and if you should have some leisure, I shall be glad if you will look over this little work of mine, *De Pictura*, which I did into Tuscan for you.[3] You will see that there are three books. The first, which is entirely mathematical, shows how this noble and beautiful art arises from roots within Nature herself. The second puts the art into the hands of the artist, distinguishes its parts and explains them all. The third instructs the artist how he may and should attain complete mastery and understanding of the art of painting. Please, therefore, read my work carefully, and if anything seems to you to need amendment, correct it. No writer was ever so well informed that learned friends were of no use to him: and I want above all to be corrected by you, so as not to be criticized by detractors.

DEDICATION OF *DE PICTURA*
To Giovan Francesco Illustrious Prince of Mantua[4]

═══════════════════

I WISHED to present you with these books on painting, illustrious prince, because I observed that you take the greatest pleasure in these liberal arts; to which you will see from the books themselves, when you have leisure to read them, how much light and learning I have brought with my natural talents and industry. As you rule over a city so peaceful and well governed by your virtue that you do not lack occasional leisure from public affairs to devote to your customary pursuit of the study of letters, I hope, with your usual kindness, in which no less than in the glory of arms and the skills of letters you excel by far all other princes, you will consider my books not unworthy of your attention. You will see they are such that their contents may prove worthy by their art of the ears of learned men, and may also easily please scholars by the novelty of their subject. But I will say no more of them here. You could know my character and learning, and all my qualities best, if you arranged for me to join you, as I indeed desire. And I shall believe my work had not displeased you, if you decide to enrol me as a devoted member among your servants and to regard me as not one of the least.

ON PAINTING
Book I

1. IN WRITING about painting in these short books, we will, to make our discourse clearer, first take from mathematicians those things which seem relevant to the subject. When we have learned these, we will go on, to the best of our ability, to explain the art of painting from the basic principles of nature. But in everything we shall say I earnestly wish it to be borne in mind that I speak in these matters not as a mathematician but as a painter. Mathematicians measure the shapes and forms of things in the mind alone and divorced entirely from matter. We, on the other hand, who wish to talk of things that are visible, will express ourselves in cruder terms.[5] And we shall believe we have achieved our purpose if in this difficult subject, which as far as I can see has not before been treated by anyone else, our readers have been able to follow our meaning. I therefore ask that my work be accepted as the product not of a pure mathematician but only of a painter.

2. The first thing to know is that a point is a sign which one might say is not divisible into parts. I call a sign anything which exists on a surface so that it is visible to the eye. No one will deny that things which are not visible do not concern the painter, for he strives to represent only the things that are seen. Points joined together continuously in a row constitute a line. So for us a line will be a sign whose length can be divided into parts, but it will be so slender in width that it cannot be split. Some lines are called straight, others curved. A straight line is a sign extended lengthways directly from one point to another. A curved line is one

which runs from point to point not along a direct path but making a bend. If many lines are joined closely together like threads in cloth, they will create a surface. A surface is the outer limit of a body which is recognized not by depth but by width and length, and also by its properties. Some of these properties are so much part of the surface that they cannot be removed or parted from it without the surface being changed. Others are ones which may present themselves to the eye in such a way that the surface appears to the beholder to have altered, when in fact the form of the surface remains unchanged. The permanent properties of surfaces are twofold. One of these we know from the outer edge in which the surface is enclosed. *Some call this the 'horizon': we will use a metaphorical term from Latin and call it the brim, or the fringe* [i.e. outline].[6] This outline will be composed of one or more lines: of one line as in a circle, or of more than one, for example, one straight and one curved line, or even several straight or curved lines. The circular line is the one which encloses a complete circle. And a circle is that form of surface which a line surrounds like a crown, so that if there were a point in the centre, all radiuses drawn directly from that point to the crown would be equal. This median point is called the centre of the circle. The straight line that cuts the crown of the circle twice and passes through the centre, is called by mathematicians the diameter. Let us call this the centre-line; and let us accept here what mathematicians tell us, that no line makes equal angles at the crown of the circle except the straight line which passes through the centre.

3. But let us come back to surfaces. From what I have said above, it can easily be understood that, if the course of the outline is altered, the surface loses its shape and original description, and what before maybe was called a triangle will now be known as a quadrangle or a figure of several angles. The outline will be said to be altered if the angles or lines in it become, not simply more numerous, but in some way either more obtuse or longer or more acute or shorter. This suggests we ought to say something here about angles. An angle is the extremity of a surface made up of two mutually intersecting lines. There are three kinds of angles:

right angle, obtuse angle and acute angle. A right angle is any one of the four which is described by two straight lines intersecting each other in such a way that each angle is equal to the other three. This is why they say that all right angles are equal. An obtuse angle is one which is greater than a right angle. An acute angle is one that is less than a right angle.

4. Let us come back to surfaces again. We explained how one property of a surface is bound up with the outline. We must now speak of the other property of a surface, which, if I might put it this way, is like a skin stretched over the whole extent of the surface. It is divided into three kinds. One is said to be uniform and plane, another raised in the middle and spherical, and the third sunk in and concave. Fourthly there should be added surfaces made up of two of these three. I will speak of them later. I am now concerned with the first three. A plane surface is one which, if you put a straight ruler on it, it touches in every part. A surface like this would be that of clear water. A spherical surface is like the outside of a sphere. A sphere is defined as a circular body, round in every way, at whose centre is a point from which all the outermost parts of that body are equidistant. A concave surface is the one which lies inside, as it were, underneath the last outer layer of a sphere, as for example the inner surfaces of eggshells. A composite surface is one which in one dimension resembles a plane, and in the other either the concave or spherical, as is the case with the inner surfaces of pipes or the outer surfaces of columns.

5. As we have explained, the properties inherent in the periphery and conformation of bodies have determined the names given to surfaces. Now the properties which, even when there is no change in the surface itself, do not always present the same aspect, are of two kinds, for they may seem to the observer to vary according to changes in position and lighting. We must first speak of position, then of lighting. And we must investigate how it is that, with change of position, the properties inherent in a surface appear to be altered. These matters are related to the power of vision; for with a change of position surfaces will appear larger, or of a completely different outline from before, or diminished

in colour; all of which we judge by sight. Let us inquire why this is so, and start from the opinion of philosophers who say that surfaces are measured by certain rays, ministers of vision as it were, which they therefore call visual rays, since by their agency the images of things are impressed upon the senses. These rays, stretching between the eye and the surface seen, move rapidly with great power and remarkable subtlety, penetrating the air and rare and transparent bodies until they encounter something dense or opaque where their points strike and they instantly stick. Indeed among the ancients there was considerable dispute as to whether these rays emerge from the surface or from the eye. This truly difficult question, which is quite without value for our purposes, may here be set aside. Let us imagine the rays, like extended very fine threads gathered tightly in a bunch at one end, going back together inside the eye where lies the sense of sight (Fig. 1). There they are like a trunk of rays from which, like straight shoots, the rays are released and go out towards the surface in front of them. But there is a difference between these rays which I think it essential to understand. They differ in strength and function, for some reach to the outlines of surfaces and measure all their dimensions. Let us call these extrinsic rays, since they fly out to touch the outer parts of the surface. Other rays, whether received by or flowing from the whole extent of the surface, have their particular function within the pyramid of which we shall presently speak, for they are imbued with the same colours and lights with which the surface itself shines. Let us, therefore, call these median rays. Among them there is one which is called the centric ray, on the analogy of the centric line we spoke of above, because it meets the surface in such a way that it makes equal angles on all sides. So we have found three kinds of rays: extrinsic, median and centric.

6. Let us now investigate what part each of these rays plays in the action of sight; first the extrinsic, then the median, and finally the centric. Quantities are measured by the extrinsic rays. A quantity is the space across the surface between two different points on the outline, which the eye measures with the extrinsic rays rather like

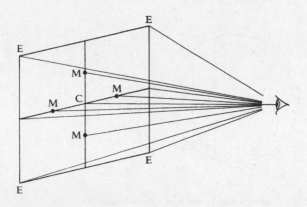

Figure 1 *The visual pyramid*
C : point at which the centric ray strikes the plane.
M : points at which the median rays strike the plane.
E : points at which the extrinsic rays touch the outer boundaries of the plane.

a pair of dividers. There are as many quantities in a surface as there are points on the outline that are in some way opposed to one another. We use these extrinsic rays whenever we apprehend by sight the height from top to bottom, or width from left to right, or depth from near to far, or any other dimensions. This is why it is usually said that sight operates by means of a triangle whose base is the quantity seen, and whose sides are those same rays which extend to the eye from the extreme points of that quantity. It is perfectly true that no quantity can be seen without such a triangle. The sides of the visual triangle, therefore, are open. In this triangle two of the angles are at the two ends of the quantity; the third is the one which lies within the eye and opposite the base. *This is not the place to argue whether sight rests at the juncture of the inner nerve of the eye, or whether images are represented on the surface of the eye, as it were in an animate mirror. I do not think it necessary here to speak of all the functions of the eye in relation to vision. It will be enough in these books to describe briefly those things that are essential to the present purpose. As, then, the* visual angle resides in the eye, the following rule has been drawn:

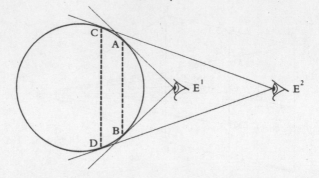

Figure 2 *A spherical body viewed from different distances*
With the eye at E^1, only the surface in front of AB will be visible. With the eye at
E^2, the surface in front of CD will be visible and more of the sphere will be visible.

the more acute the angle within the eye, the less will appear the
quantity. From this it can be clearly understood why it is that
at a great distance a quantity seems to be reduced to a point.
None the less it does happen with some surfaces that the nearer
the eye of the observer is to it, the less it sees, and the further
away it is, the greater the part of the surface it sees. This is seen
to be the case with a spherical surface (Fig. 2). Quantities, there-
fore, sometimes seem to the observer greater or lesser according
to their distance. Anyone who has properly understood the
theory behind this, will plainly see that some median rays some-
times become extrinsic, and extrinsic ones median, when the
distance is changed; and he will appreciate that where the
median have become extrinsic, the quantity will appear less,
and conversely, when the extrinsic rays fall inside the outline,
the further they are from it, the greater the quantity appears.
7. I usually give my friends the following rule: the more rays are
employed in seeing, the greater the quantity seen will appear, and
the fewer the rays, the smaller the quantity. Furthermore, the
extrinsic rays, which hold on like teeth to the whole of the
outline, form an enclosure around the entire surface like a cage.
This is why they say that vision takes place by means of a pyramid

of rays. We must, therefore, explain what a pyramid is, and how it is made up of rays. Let us describe it in our own rough terms. A pyramid is a form of oblong body from whose base all straight lines, prolonged upwards, meet at one and the same point. The base of the pyramid is the surface seen, and the sides are the visual rays we said are called extrinsic. The vertex of the pyramid resides within the eye, where the angles of the quantities in the various triangles meet together. Up to now we have dealt with the extrinsic rays of which the pyramid is composed; from all of which it is evident that it is of considerable importance what distance lies between the surface and the eye. We must now speak of the median rays. These are the mass of rays which is contained within the pyramid and enclosed by the extrinsic rays. These rays do what they say the chameleon and other like beasts are wont to do when struck with fear, who assume the colours of nearby objects so as not to be easily discovered by hunters. These median rays behave likewise; for, from their contact with the surface to the vertex of the pyramid, they are so tinged with the varied colours and lights they find there, that at whatever point they were interrupted, they would show the same light they had absorbed and the same colour. We know for a fact about these median rays that over a long distance they weaken and lose their sharpness. The reason why this occurs has been discovered: as they pass through the air, these and all the other visual rays are laden and imbued with lights and colours; but the air too is also endowed with a certain density, and in consequence the rays get tired and lose a good part of their burden as they penetrate the atmosphere. So it is rightly said that the greater the distance, the more obscure and dimmed the surface appears.

8. It remains for us to speak of the centric ray. We call the centric ray the one which alone strikes the quantity in such a way that the adjacent angles on all sides are equal. As for the properties of the centric ray, it is of all the rays undoubtedly the most keen and vigorous. It is also true that a quantity will never appear larger than when the centric ray rests upon it. A great deal could be said about the power and function of this ray. One thing

should not go unsaid: this ray alone is supported in their midst, like a united assembly, by all the others, so that it must rightly be called the leader and prince of rays. *Further comment would be more appropriate to a show of learning than to the things we set out to treat, and may therefore be omitted here. Besides, much will be said about rays more suitably in their proper place. Let it suffice here, as the brevity of these books requires, to have stated those things that will leave no one doubting the truth of what I believe* I have adequately shown, *namely*, if the distance and position of the centric ray are changed, the surface appears to be altered. For it will appear either smaller or larger or changed according to the relative disposition of the lines and angles. So the position of the centric ray and distance play a large part in the determination of sight. There is also a third condition in which surfaces present themselves to the observer as different or of diverse form. This is the reception of light. One can observe in a spherical or concave body, if there is only one source of light present, that the surface is rather dark in one part and lighter in another, whilst at the same distance and with no change of the original centric position, if the same surface lies in a different light from before, you will see as dark the parts which were bright before under the other light, and as light those parts that earlier were in the shadow. Then, if there are several lights around, various patches of brightness and darkness will alternate here and there according to the number and strength of the lights. This can be verified by experiment.

9. At this juncture we ought to say something about lights and colours. It is evident that colours vary according to light, as every colour appears different when in shade and when placed under rays of light. Shade makes a colour look dimmer, and light makes it bright and clear. Philosophers say that nothing is visible that is not endowed with light and colour. There is, then, a very close relationship between colours and lights in the function of sight; and the extent of this can be observed in the fact that as the light disappears, so also do the colours, and when it returns, the colours come back along with the strength of the light. This being so, we must first take a look at colours. Then we will investigate how

colours vary according to light. *Let us leave aside the disputes of philosophers regarding the origins of colours. For what help is it to the painter to know how colour is made from the mixture of rare and dense, or hot and dry and cold and wet? Yet I would not regard those philosophers unworthy of respect who maintain that the kinds of colours are seven in number. They set white and black as the two extremes, and another half-way between; then on both sides, between this middle one and each extreme, they put a pair of others, with some uncertainty about their boundaries, though one of each pair is more like the related extreme than the other. It is enough for the painter to know what the colours are, and how they should be used in painting. I would not wish to be contradicted by those more expert than myself, who, while following the philosophers, nonetheless assert that in the nature of things there are only two true colours, white and black, and all the rest arise from the mixture of these two. My own view about colours, as a painter, is that from the mixture of colours there arises an almost infinite variety of others, but that* for painters there are four true genera of colours corresponding to the number of the elements, and from these many species are produced. There is fire-colour, which they call red, and the colour of air which is said to be blue-grey, and the green of water, and the earth is ash-coloured. We see that all the other colours, like jasper and porphyry stone, are made from a mixture. So, there are four kinds of colours, of which there are countless species according to the admixture of white and black. For we see verdant leaves gradually lose their greenness until they become white. We also see the same thing with the air, how, when, as if often the case, it is suffused around the horizon with whitish mist, it gradually changes back to its true colour. Then, with roses we see too that some are a rich bright red, others are like the cheeks of maidens, and others resemble pale ivory. The colour of earth also has its species according to the mixture of white and black.

10. The admixture of white, therefore, does not alter the basic genera of colours, but creates species. Black has a similar power, for many species of colours arise from the addition of black. This is evident from the effect of shade on colour, for as shade deepens, the clarity and whiteness of a colour become less, and when the

light increases, the colour becomes clear and brighter. The painter, therefore, may be assured that white and black are not true colours but, one might say, moderators of colours, for the painter will find nothing but white to represent the brightest glow of light, and only black for the darkest shadows. Furthermore, you will not find any white or black that does not belong to one or other of the genera of colours.

11. Now we will speak of the effect of lights. Some are of stars, such as the sun and the moon and the morning-star, others of lamps and fire. There is a great difference between them, for the light of stars makes shadows exactly the same size as bodies, while the shadows from fire are larger than the bodies (Fig. 3). A shadow is made when rays of light are intercepted. Rays that are intercepted are either reflected elsewhere or return upon themselves. They are reflected, for instance, when they rebound off the surface of water onto the ceiling; *and, as mathematicians prove, reflection of rays always takes place at equal angles.* But these are matters that concern another aspect of painting.[7] Reflected rays assume the colour they find on the surface from which they are reflected. We see this happen when the faces of people walking about in the meadows appear to have a greenish tinge.

12. I have spoken about surfaces and about rays. I have explained how, in seeing, a pyramid is made up of triangles. We have shown how extremely important it is that the distance, the position of the centric ray, and the reception of light should be determined. But as at one glance we see not merely one but several surfaces together, now that we have dealt in some detail with single surfaces, we must enquire in what way surfaces that are connected together present themselves. As we have said, individual surfaces enjoy their own pyramid charged with its particular colours and lights. Since bodies are covered in surfaces, all the observed quantities of bodies will make up a single pyramid containing as many small pyramids as there are surfaces embraced by the rays from that point of vision. Even so, someone may ask what practical advantage all this inquiry brings to the painter. It is this: he must understand that he will become an excellent artist only if

Figure 3 *Shadows arising from different light sources*
(i) Light in parallel rays from the sun and stars produces a shadow equal in size to the body.
(ii) Light from a small, adjacent, artificial source produces a shadow larger than the body.

he knows well the borderlines of surfaces and their proportions, which very few do; for if they are asked what they are attempting to do on the surface they are painting, they can answer more correctly about everything else than about what in this sense they are doing. So I beg studious painters to listen to me. It was never

shameful to learn from any teacher things that are useful to know. They should understand that, when they draw lines around a surface, and fill the parts they have drawn with colours, their sole object is the representation on this one surface of many different forms of surfaces, just as though this surface which they colour were so transparent and like glass, that the visual pyramid passed right through it from a certain distance and with a certain position of the centric ray and of the light, established at appropriate points nearby in space. Painters prove this when they move away from what they are painting and stand further back, seeking to find by the light of nature the vertex of the pyramid from which they know everything can be more correctly viewed. But as it is only a single surface of a panel or a wall, on which the painter strives to represent many surfaces contained within a single pyramid, it will be necessary for his visual pyramid to be cut at some point, so that the painter by drawing and colouring can express whatever outlines and colours that intersection presents. Consequently the viewers of a painted surface appear to be looking at a particular intersection of the pyramid. Therefore, a painting will be the intersection of a visual pyramid at a given distance, with a fixed centre and certain position of lights, represented by art with lines and colours on a given surface.

13. Having said that painting represents the intersection of a pyramid, we must now examine all those things that enable us to understand that intersection. We must, therefore, say something further about the surfaces from which, as we have shown, the pyramids to be intersected in the painting arise. Some surfaces lie horizontally before one, like the floors of buildings and other surfaces equidistant from the floor. Others stand perpendicularly, such as walls and other surfaces collinear with them. Surfaces are said to be equidistant from one another when the distance between them is the same at every point (Fig. 4). Collinear surfaces are those which a continuous straight line touches equally in every part, like the surfaces of square columns standing in regular succession in an arcade. These remarks should be added to what we said above about surfaces. And to what we said about extrinsic,

Figure 4 *'Equidistant' and 'collinear' quantities*
(i) Plan of square objects in 'equidistant' rows, i.e. AB is parallel to CD.
(ii) Plan of square objects in a 'collinear' row, i.e. their faces are in a straight line along EF.

median and centric rays, about the visual pyramid, should be added the mathematical proposition that if a straight line intersects two sides of a triangle, and this intersecting line, which forms a new triangle, is equidistant from one of the sides of the first triangle, then the greater triangle will be proportional to the lesser. This is what mathematicians affirm.

14. In order to make our argument clearer, we will explain this position more fully. Here it is necessary for the painter to know what is meant by proportional. We say that triangles are proportional when their sides and angles stand in the same relationship to each other, because, if one side of a triangle is two and a half times as long as the base and the other three times, then all similar triangles, whether they are larger or smaller, will for us be proportional to one another, provided they have the same correspondence between the sides and the base, since the ratio of one part to another in the greater triangle is the same also in the lesser. Therefore triangles constructed in this way are all proportional. In

Figure 5 *Similar triangles* (All the triangles have similar angles)
AB or AC : BC = DE or DF : EF
GH or GI : HI = GJ or GK : JK

order that this may be even more clearly understood, we will employ a comparison. A very small man is proportional to a very large one; for there was the same proportion of span to stride, and of foot to the remaining parts of the body in Evander as there was in Hercules, whom Gellius conjectures was taller and bigger than other men.[8] Yet, the proportion of the limbs of Hercules was no different from that of the body of the giant Antaeus, since the symmetry from the hand to the elbow, and the elbow to the head, and all the other members, corresponded in both in similar ratio. Similarly in triangles, there can be a certain uniformity between them, whereby the lesser agrees with the greater in all respects except in size. If this is now clear, we may accept the mathematicians' proposition as far as it serves our purpose, and conclude that every intersection of any triangle equidistant from its base will create a triangle proportional to the larger triangle (Fig. 5). In things which are proportional to one another, all the parts correspond; but those which have different and incongruous parts are in no sense proportional.

15. The parts of the visual triangle are the angles and the rays, which in proportional quantities will be equal, and in non-proportional quantities unequal; for any one of these non-proportional

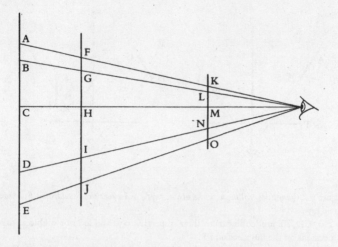

Figure 6 *Proportional intervals produced by parallel intersections of visual pyramid*
AB : BC : CD : DE = FG : GH : HI : IJ = KL : LM : MN : NO

quantities seen will occupy either more or less rays. You have seen how any lesser triangle may be proportional to a greater, and remember that the visual pyramid is made up of triangles. So all we have said about triangles may be transferred to the pyramid, and we may be sure that no quantities of the surface that are equidistant from the intersection of the pyramid, undergo any change in the painting; for those equidistant quantities are equal, at any equidistant intersection, to those proportional to them. From this it follows that if the quantities that make up the outline of a surface are not changed, there occurs no change in that outline in the painting. And so it is clear that any intersection of the visual pyramid equidistant from the surface seen is proportional to that surface (Fig. 6).

16. We have spoken of the surfaces proportional to the intersection, that is, equidistant from the painting surface. But as many surfaces are not equidistant from the painting surface, we must inquire carefully into these, so that the entire system of the intersection may be made clear. Yet it would be a long, difficult, and extremely

Figure 7 *Quantities 'collinear to the visual rays', and quantities 'equidistant from some visual rays'*

(i) AB, CD, EF are 'collinear' to their respective rays and are not visible as finite dimensions on the intersection PP.

(ii) GH, IJ, KL are 'equidistant' from (i.e. parallel to) some visual rays. GH is parallel to the ray T. IJ is parallel to the ray R. KL is parallel to the ray S. GH, IJ, KL occupy spaces on the intersection PP relative to the angles they make with the rays that strike them.

involved task to pursue all the mathematicians' rules in these intersections of triangles and the pyramid. Let us proceed to deal with the matter as painters.

17. Let us briefly say something about non-equidistant quantities, from an understanding of which it will be easy to learn all about the non-equidistant surface. Of non-equidistant quantities some are collinear to the visual rays, others are equidistant from some visual rays (Fig. 7). Quantities collinear to the rays occupy no room at the intersection, as they make no triangle and occupy no number of rays. But in quantities equidistant from the visual rays, the more obtuse the greater angle is at the base of the triangle, the fewer the rays that quantity will occupy, and consequently the less space it will take up at the intersection. We have said that surfaces were covered in quantities; but as it not infrequently happens in surfaces that there are some quantities equidistant from the intersection, while the rest are not, for this reason only those that are equidistant undergo no change in the painting, and the

non-equidistant quantities suffer the more alteration, the more obtuse is the greater angle of their triangle at the base.

18. To all these remarks should be added the belief of philosophers that if the sky, the stars, the seas, the mountains and all living creatures, together with all other objects, were, the gods willing, reduced to half their size, everything that we see would in no respect appear to be diminished from what it is now. Large, small, long, short, high, low, wide, narrow, light, dark, bright, gloomy, and everything of the kind – which philosophers termed accidents, because they may or may not be present in things – all these are such as to be known only by comparison. Virgil says that Aeneas stands head and shoulders above other men, but if compared with Polyphemus, he will seem a pygmy.[9] They say that Euryalus was most beautiful, but if compared with Ganymede, who was carried off by the gods, he might appear to be ugly.[10] The Spaniards think many young maidens fair, whom the Germans would regard as swarthy and dark. Ivory and silver are white, but compared to the swan or snow-white linen, they appear rather pale. For this reason, surfaces will appear very clear and bright in a painting when there is the same proportion of white to black in it as there is of light to shade in objects themselves. All these things, then, are learned by comparison. There is in comparison a power which enables us to recognize the presence of more or less or just the same. So we call large what is bigger than this small thing, and very large what is bigger than the large, and bright what is lighter than this dark object, and very bright what is brighter than the light. Comparison is made with things most immediately known. As man is the best known of all things to man, perhaps Protagoras, in saying that man is the scale and the measure of all things, meant that accidents in all things are duly compared to and known by the accidents in man.[11] All of which should persuade us that, however small you paint the objects in a painting, they will seem large or small according to the size of any man in the picture. Of all the ancients, the painter Timanthes always seems to me to have observed this force of comparison best. They say that he represented on a small panel a Cyclops asleep, and put in next

to him some satyrs embracing his thumb, so that the sleeping figure appeared very large indeed in proportion to the satyrs.[12]

19. Up to now we have explained everything related to the power of sight and the understanding of the intersection. But as it is relevant to know, not simply what the intersection is and what it consists in, but also how it can be constructed, we must now explain the art of expressing the intersection in painting. Let me tell you what I do when I am painting. First of all, on the surface on which I am going to paint, I draw a rectangle of whatever size I want, which I regard as an open window through which the subject to be painted is seen; and I decide how large I wish the human figures in the painting to be (Fig. 8). I divide the height of this man into three parts, which will be proportional to the measure commonly called a 'braccio'; for, as may be seen from the relationship of his limbs, three 'braccia' is just about the average height of a man's body.[13] With this measure I divide the bottom line of my rectangle into as many parts as it will hold; and this bottom line of the rectangle is for me proportional to the nearest transverse equidistant quantity seen on the pavement. Then I establish a point in the rectangle wherever I wish; and as it occupies the place where the centric ray strikes, I shall call this the centric point. The suitable position for this centric point is no higher from the base line than the height of the man to be represented in the painting, for in this way both the viewers and the objects in the painting will seem to be on the same plane. Having placed the centric point, I draw straight lines from it to each of the divisions on the base line. These lines show me how successive transverse quantities visually change to an almost infinite distance. At this stage some would draw a line across the rectangle equidistant from the divided line, and then divide the space between these two lines into three parts (Fig. 9). Then, to that second equidistant line they would add another above, following the rule that the space which is divided into three parts between the first divided (base) line and the second equidistant one, shall exceed by one of its parts the space between the second and

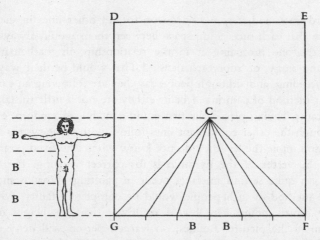

Figure 8 *Construction of perspective, first stage: parallels drawn to the 'centric point'*
DEFG : boundary of the picture or 'window'. B : *braccio* divisions corresponding
on the scale of the picture to one-third of a man's height. C : 'centric point'. *Braccio*
divisions along FG are joined to C.

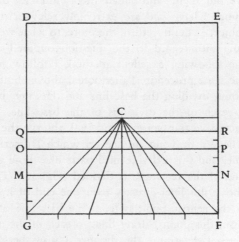

Figure 9 *Incorrect way of establishing the horizontals*
GM = 3 units, and MO = 2 units; NP = 3 new units, and PR = 2 new units; and so
on, successively.

third lines; and they would go on to add other lines in such a way that each succeeding space between them would always be to the one preceding it in the relationship, in mathematical terminology, of 'superbipartiens'.[14] That would be their way of proceeding, and although people say they are following an excellent method of painting, I believe they are not a little mistaken, because, having placed the first equidistant line at random, even though the other equidistant lines follow with some system and reason, none the less they do not know where the fixed position of the vertex of the pyramid is for correct viewing. For this reason quite serious mistakes occur in painting. What is more, the method of such people would be completely faulty, where the centric point were higher or lower than the height of a man in the picture. Besides, no learned person will deny that no objects in a painting can appear like real objects, unless they stand to each other in a determined relationship. We will explain the theory behind this if ever we write about the demonstrations of painting, which our friends marvelled at when we did them, and called them 'miracles of painting'; for the things I have said are extremely relevant to this aspect of the subject.[15] Let us return, therefore, to what we were saying.

20. With regard to the question outlined above, I discovered the following excellent method. I follow in all other respects the same procedure I mentioned above about placing the centre point, dividing the base line and drawing lines from that point to each of the divisions of the base line. But as regards the successive transverse quantities I observe the following method. I have a drawing surface on which I describe a single straight line, and this I divide into parts like those into which the base line of the rectangle is divided (Fig. 10). Then I place a point above this line, directly over one end of it, at the same height as the centric point is from the base line of the rectangle, and from this point I draw lines to each of the divisions of the line. Then I determine the distance I want between the eye of the spectator and the painting, and, having established the position of the intersection at this distance, I effect the intersection with

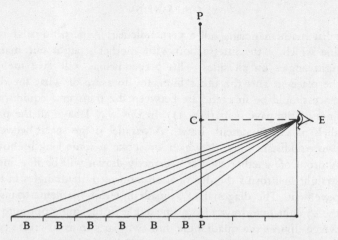

Figure 10 *Construction of perspective, second stage; determination of the horizontal divisions on the intersection*

B : *braccio* divisions on the 'pavement'. PP : intersection or picture plane. C : 'centric point'. E : eye, three *braccia* from the intersection. The viewing distance, EC, is equivalent to half the width of the picture and the viewing angle is 90° (i.e. the shortest reasonable distance before serious distortions start to occur).

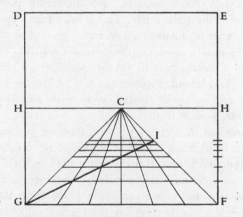

Figure 11 *Construction of perspective, third stage: completion of the squared 'pavement'* DEFG : picture. C : 'centric point'. HH : horizon. The intervals on the intersection PP in Fig. 10 are transferred to HF (or HG), and the successive horizontals of the 'pavement' are drawn at corresponding levels. GI : diagonal through the squares, drawn as proof of the accuracy of the construction.

what mathematicians call a perpendicular. A perpendicular is a line which at the intersection with another straight line makes right angles on all sides. This perpendicular will give me, at the places it cuts the other lines, the measure of what the distance should be in each case between the transverse equidistant lines of the pavement (Fig. 11). In this way I have all the parallels of the pavement drawn. A parallel is the space between two equidistant lines, of which we spoke at some length above. A proof of whether they are correctly drawn will be if a single straight line forms the diagonal of connected quadrangles in the pavement. The diagonal of a quadrangle for mathematicians is the straight line drawn from one angle to the angle opposite it, which divides the quadrangle into two parts so as to create two triangles from it. When I have carefully done these things, I draw a line across, equidistant from the other lines below, which cuts the two upright sides of the large rectangle and passes through the centric point. This line is for me a limit or boundary, which no quantity exceeds that is not higher than the eye of the spectator. As it passes through the centric point, this line may be called the centric line. This is why men depicted standing in the parallel furthest away are a great deal smaller than those in the nearer ones – a phenomenon which is clearly demonstrated by nature herself, for in churches we see the heads of men walking about, moving at more or less the same height, while the feet of those further away may correspond to the knee-level of those in front.

21. This method of dividing up the pavement pertains especially to that part of painting which, when we come to it, we shall call composition; and it is such that I fear it may be little understood by readers on account of the novelty of the subject and the brevity of our description. As we can easily judge from the works of former ages, this matter probably remained completely unknown to our ancestors because of its obscurity and difficulty. You will hardly find any 'historia' of the ancients properly composed either in painting or modelling or sculpture.

22. I have set out the foregoing briefly and, I believe, in a not

altogether obscure fashion, but I realize the content is such that, while I can claim no praise for eloquence in exposition, the reader who does not understand at first acquaintance, will probably never grasp it however hard he tries. To intelligent minds that are well disposed to painting, those things are simple and splendid, however presented, which are disagreeable to gross intellects little disposed to these noble arts, even if expounded by the most eloquent writers. As they have been explained by me briefly and without eloquence, they will probably not be read without some distaste. Yet I crave indulgence if, in my desire above all to be understood, I saw to it that my exposition should be clear rather than elegant and ornate. What follows will, I hope, be less disagreeable to the reader.

23. I have set out whatever seemed necessary to say about triangles, the pyramid and the intersection. I used to demonstrate these things at greater length to my friends with some geometrical explanation.[16] I considered it best to omit this from these books for reasons of brevity. I have outlined here, as a painter speaking to painters, only the first rudiments of the art of painting. And I have called them rudiments, because they lay the first foundations of the art for unlearned painters. They are such that whoever has grasped them properly will see they are of considerable benefit, not only to his own talent and to understanding the definition of painting, but also to the appreciation of what we are going to say later on. Let no one doubt that the man who does not perfectly understand what he is attempting to do when painting, will never be a good painter. It is useless to draw the bow, unless you have a target to aim the arrow at. I want us to be covinced that he alone will be an excellent painter who has learned thoroughly to understand the outlines and all the properties of surfaces. On the other hand, I believe that he who has not diligently mastered all we have said, will never be a good artist.

24. These remarks on surfaces and intersection were, therefore, essential for our purposes. We will now go on to instruct the painter how he can represent with his hand what he has understood with his mind.

Book II

25. AS THE effort of learning may perhaps seem to the young too laborious, I think I should explain here how painting is worthy of all our attention and study. Painting possesses a truly divine power in that not only does it make the absent present (as they say of friendship), but it also represents the dead to the living many centuries later, so that they are recognized by spectators with pleasure and deep admiration for the artist. Plutarch tells us that Cassandrus, one of Alexander's commanders, trembled all over at the sight of a portrait of the deceased Alexander, in which he recognized the majesty of his king. He also tells us how Agesilaus the Lacedaemonian, realizing that he was very ugly, refused to allow his likeness to be known to posterity, and so would not be painted or modelled by anyone.[17] Through painting, the faces of the dead go on living for a very long time. We should also consider it a very great gift to men that painting has represented the gods they worship, for painting has contributed considerably to the piety which binds us to the gods, and to filling our minds with sound religious beliefs. It is said that Phidias made a statue of Jove in Elis, whose beauty added not a little to the received religion.[18] How much painting contributes to the honest pleasures of the mind, and to the beauty of things, may be seen in various ways but especially in the fact that you will find nothing so precious which association with painting does not render far more valuable and highly prized. Ivory, gems, and all other similar precious things are made more valuable by the hand of the

painter. Gold too, when embellished by the art of painting, is equal in value to a far larger quantity of gold. Even lead, the basest of metals, if it were formed into some image by the hand of Phidias or Praxiteles, would probably be regarded as more precious than rough unworked silver. The painter Zeuxis began to give his works away, because, as he said, they could not be bought for money.[19] He did not believe any price could be found to recompense the man who, in modelling or painting living things, behaved like a god among mortals.

26. The virtues of painting, therefore, are that its masters see their works admired and feel themselves to be almost like the Creator. Is it not true that painting is the mistress of all the arts or their principal ornament? If I am not mistaken, the architect took from the painter architraves, capitals, bases, columns and pediments, and all the other fine features of buildings. The stonemason, the sculptor and all the workshops and crafts of artificers are guided by the rule and art of the painter. Indeed, hardly any art, except the very meanest, can be found that does not somehow pertain to painting. So I would venture to assert that whatever beauty there is in things has been derived from painting. *Painting was honoured by our ancestors with this special distinction that, whereas all other artists were called craftsmen, the painter alone was not counted among their number.* Consequently I used to tell my friends that the inventor of painting, according to the poets, was Narcissus, who was turned into a flower; for, as painting is the flower of all the arts, so the tale of Narcissus fits our purpose perfectly. What is painting but the act of embracing by means of art the surface of the pool? Quintilian believed that the earliest painters used to draw around shadows made by the sun, and the art eventually grew by a process of additions.[20] Some say that an Egyptian Philocles and a certain Cleanthes were among the first inventors of this art. The Egyptians say painting was practised in their country six thousand years before it was brought over into Greece. Our writers say it came from Greece to Italy after the victories of Marcellus in Sicily.[21] But it is of little concern to us to discover the first painters or the inventors of the art, since we are not writing a

history of painting like Pliny, but treating of the art in an entirely new way. On this subject there exist today none of the writings of the ancients, as far as I have seen, although they say that Euphranor the Isthmian wrote something about symmetry and colours, that Antigonus and Xenocrates set down some words about paintings, and that Apelles wrote on painting to Perseus. Diogenes Laertius tells us that the philosopher Demetrius also wrote about painting.[22] Since all the other liberal arts were committed to writing by our ancestors, I believe that painting too was not neglected by our authors of Italy, for the ancient Etruscans were the most expert of all in Italy in the art of painting.

27. The ancient writer Trismegistus believes that sculpture and painting originated together with religion. *He addresses Asclepius with these words: 'Man, mindful of his nature and origin, represented the gods in his own likeness'.*[23] Yet who will deny that painting has assumed the most honoured part in all things both public and private, profane and religious, to such an extent that no art, I find, has been so highly valued universally among men? Almost incredible prices are quoted for painted panels. The Theban Aristides sold one painting alone for a hundred talents. They say that Rhodes was not burned down by King Demetrius lest a painting by Protogenes be destroyed.[24] So we can say that Rhodes was redeemed from the enemy by a single picture. Many other similar tales were collected by writers, from which you can clearly see that good painters always and everywhere were held in the highest esteem and honour, so that even the most noble and distinguished citizens and philosophers and kings took great pleasure not only in seeing and possessing paintings, but also in painting themselves. L. Manilius, a Roman citizen, and the nobleman Fabius were painters. Turpilius, a Roman knight, painted at Verona. Sitedius, praetor and proconsul, acquired fame in painting. Pacuvius, the tragedian, nephew of the poet Ennius, painted Hercules in the forum.[25] The philosophers Socrates, Plato, Metrodorus and Pyrrho achieved distinction in painting.[26] The emperors Nero, Valentinianus and Alexander Severus were very devoted to painting.[27] It would be a long story to tell how many princes

or kings have devoted themselves to this most noble art. Besides, it is not appropriate to review all the multitude of ancient painters. Its size may be understood from the fact that for Demetrius of Phalerum, son of Phanostratus, three hundred and sixty statues were completed within four hundred days, some on horseback and some in chariots.[28] In a city in which there was so large a number of sculptors, shall we not believe there were also many painters? Painting and sculpture are cognate arts, nurtured by the same genius. But I shall always prefer the genius of the painter, as it attempts by far the most difficult task. Let us return to what we were saying.

28. The number of painters and sculptors was enormous in those days, when princes and people, and learned and unlearned alike delighted in painting, and statues and pictures were displayed in the theatres among the chief spoils brought from the provinces. Eventually Paulus Aemilius and many other Roman citizens taught their sons painting among the liberal arts in the pursuit of the good and happy life.[29] The excellent custom was especially observed among the Greeks that free-born and liberally educated young people were also taught the art of painting together with letters, geometry and music. Indeed the skill of painting was a mark of honour also in women. Martia, Varro's daughter, is celebrated by writers for her painting.[30] The art was held in such high esteem and honour that it was forbidden by law among the Greeks for slaves to learn to paint; and quite rightly so, for the art of painting is indeed worthy of free minds and noble intellects. I have always regarded it as a mark of an excellent and superior mind in any person whom I saw take great delight in painting. Although, this art alone is equally pleasing to both learned and unlearned; and it rarely happens in any other art that what pleases the knowledgeable also attracts the ignorant. You will not easily find anyone who does not earnestly desire to be accomplished in painting. Indeed it is evident that Nature herself delights in painting, for we observe she often fashions in marble hippocentaurs and bearded faces of kings.[31] It is also said that in a gem owned by Pyrrhus the nine Muses were clearly depicted by

Nature, complete with their insignia.[32] Furthermore, there is no other art in whose study and practice all ages of learned and unlearned alike may engage with such pleasure. Let me speak of my own experience. Whenever I devote myself to painting for pleasure, which I very often do when I have leisure from other affairs, I persevere with such pleasure in finishing my work that I can hardly believe later on that three or even four hours have gone by.

29. This art, then, brings pleasure while you practise it, and praise, riches and endless fame when you have cultivated it well. Therefore, as painting is the finest and most ancient ornament of things, worthy of free men and pleasing to learned and unlearned alike, I earnestly beseech young students to devote themselves to painting as much as they can. Next, I would advise those who are devoted to painting to go on to master with every effort and care this perfect art of painting. You who strive to excel in painting, should cultivate above all the fame and reputation which you see the ancients attained, and in so doing it will be a good thing to remember that avarice was always the enemy of renown and virtue. A mind intent on gain will rarely obtain the reward of fame with posterity. I have seen many in the very flower, as it were, of learning, descend to gain and thereafter obtain neither riches nor distinction, who if they had improved their talent with application, would easily have risen to fame and there received both wealth and the satisfaction of renown. But we have said enough on these matters. Let us return to our purpose.

30. We divide painting into three parts, and this division we learn from Nature herself. As painting aims to represent things seen, let us note how in fact things are seen. In the first place, when we look at a thing, we see it as an object which occupies a space. The painter will draw around this space, and he will call this process of setting down the outline, appropriately, circumscription. Then, as we look, we discern how the several surfaces of the object seen are fitted together; the artist, when drawing these combinations of surfaces in their correct relationship, will properly call this composition. Finally, in looking we observe more clearly the colours of

surfaces; the representation in painting of this aspect, since it receives all its variations from light, will aptly here be termed the reception of light.

31. Therefore, circumscription, composition and reception of light make up painting; and with these we must now deal as briefly as possible. First circumscription. Circumscription is the process of delineating the external outlines on the painting. They say that Parrhasius the painter, with whom Socrates speaks in Xenophon, was very expert in this and studied these lines very closely.[33] I believe one should take care that circumscription is done with the finest possible, almost invisible lines, like those they say the painter Apelles used to practise and vie with Protogenes at drawing.[34] Circumscription is simply the recording of the outlines, and if it is done with a very visible line, they will look in the painting, not like the margins of surfaces, but like cracks. I want only the external outlines to be set down in circumscription; and this should be practised assiduously. No composition and no reception of light will be praised without the presence of circumscription. But circumscription by itself is very often most pleasing. So attention should be devoted to circumscription; and to do this well, I believe nothing more convenient can be found than the veil, which among my friends I call the intersection, and whose usage I was the first to discover. It is like this: a veil loosely woven of fine thread, dyed whatever colour you please, divided up by thicker threads into as many parallel square sections as you like, and stretched on a frame. I set this up between the eye and the object to be represented, so that the visual pyramid passes through the loose weave of the veil (Fig. 12). This intersection of the veil has many advantages, first of all because it always represents the same surfaces unchanged, for once you have fixed the position of the outlines, you can immediately find the apex of the pyramid you started with, which is extremely difficult to do without the intersection. You know how impossible it is to paint something which does not continually present the same aspect. This is why people can copy paintings more easily than sculptures, as they always look the same. You also know that, if the distance and the

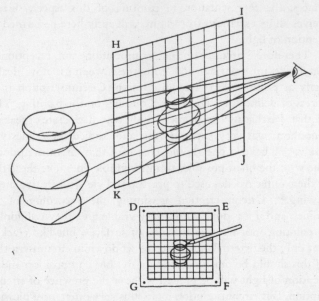

Figure 12 *The 'intersection' or 'veil'*

HIJK : veil divided into squares by thicker threads. DEFG : drawing surface divided into the same number of squares as in the veil. The points at which the image of the object intersects the squared grid are noted, and equivalent points are transcribed on to the squared drawing surface.

position of the centric ray are changed, the thing seen appears to be altered. So the veil will give you the not inconsiderable advantage I have indicated, namely that the object seen will always keep the same appearance. A further advantage is that the position of the outlines and the boundaries of the surfaces can easily be established accurately on the painting panel; for just as you see the forehead in one parallel, the nose in the next, the cheeks in another, the chin in one below, and everything else in its particular place, so you can situate precisely all the features on the panel or wall which you have similarly divided into appropriate parallels. Lastly, this veil affords the greatest assistance in executing your picture, since you can see any object that is round and in

relief, represented on the flat surface of the veil. From all of which we may appreciate by reflection and experience how useful the veil is for painting easily and correctly.

32. I will not listen to those who say it is no good for a painter to get into the habit of using these things, because, though they offer him the greatest help in painting, they make the artist unable to do anything by himself without them. If I am not mistaken, we do not ask for infinite labour from the painter, but we do expect a painting that appears markedly in relief and similar to the objects presented. I do not understand how anyone could ever even moderately achieve this without the help of the veil. So those who are anxious to advance in the art of painting, should use this intersection or veil, as I have explained. Should they wish to try their talents without the veil, they should imitate this system of parallels with the eye, so that they always imagine a horizontal line cut by another perpendicular at the point where they establish in the picture the edge of the object they observe. But as for many inexpert painters the outlines of surfaces are vague and uncertain, as for example in faces, because they cannot determine at what point more particularly the temples are distinguished from the forehead, they must be taught how they may acquire this knowledge. Nature demonstrates this very clearly. Just as we see flat surfaces distinguished by their own lights and shades, so we may see spherical and concave surfaces divided up, as it were, in squares into several surfaces by different patches of light and shade. These individual parts, distinguished by light and shade, are therefore to be treated as single surfaces. If the surface seen proceeds from a dark colour gradually lightening to bright, then you should mark with a line the mid-point between the two parts, so that the way in which you should colour the whole area is made less uncertain.

33. It remains for us to say something further about circumscription, which also pertains in no small measure to composition. For this purpose one should know what composition is in painting. Composition is that procedure in painting whereby the parts are composed together in a picture. The great work of the painter is

the 'historia'; parts of the 'historia' are the bodies, part of the body
is the member, and part of the member is a surface. As circumscrip-
tion is the procedure in painting whereby the outlines of the
surfaces are drawn, and as some surfaces are small, as in living
creatures, while others are very large, as in buildings and giant
statues, the precepts we have given so far may suffice for drawing
the small surfaces, for we have shown that they can be measured
with the veil. For the larger surfaces a new method must be
found. In this connection one should remember all we said above
in our rudiments about surfaces, rays, pyramid and intersection.
You will also recall what I wrote about the parallels of the
pavement, and the centric point and line. On the pavement that is
divided up into parallels, you have to construct the sides of walls
and other similar surfaces which we have described as perpen-
dicular. I will explain briefly how I proceed in this construction. I
begin first from the foundations. I draw the breadth and length of
the walls on the pavement, and in doing this I observe from
Nature that more than two connected standing surfaces of any
square right-angled body cannot be seen at one glance. So in
drawing the foundations of the walls I take care that I outline only
those sides that are visible; and I always begin from the nearer
surfaces, and particularly from those that are equidistant from the
intersection. I draw these before the rest, and I determine what I
wish their length and breadth to be by the parallels traced on the
pavement, for I take up as many parallels as I want them to be
'braccia'. I find the middle of the parallels from the intersection of
the two diagonals, as the intersection of one diagonal by another
marks the middle point of a quadrangle (Fig. 13). So, from the
scale of the parallels I easily draw the width and length of walls
that rise from the ground. Then I go on from there without any
difficulty to do the heights of the surfaces, since a quantity will
maintain the same proportion for its whole height as that which
exists between the centric line and the position on the pavement
from which that quantity of the building rises. So, if you want
this quantity from the ground to the top to be four times the
height of a man in the picture, and the centric line has been placed

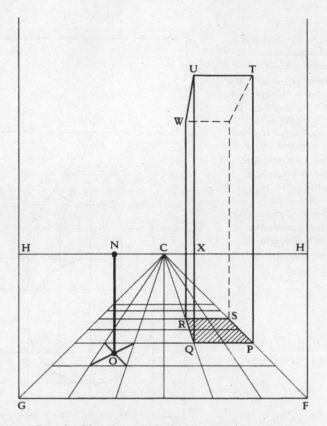

Figure 13 *Examples of the construction of scaled forms on the 'pavement'*
O : A distance of 1½ *braccia* into the picture, determined by the diagonals of a
square in the second row. ON = 3 *braccia*.
PQRS : plan of rectangular object on a base 2 *braccia* square. QX = 3 *braccia*. QU = 9
braccia (note: Alberti's example is a further 3 *braccia* high). TUW : top of the visible
faces of the object (all other labels as in Fig. 11).

at the height of a man, then it will be three 'braccia' from the foot
of the quantity to the centric line; but, as you wish this quantity
increased to twelve 'braccia', you must continue it upwards three
times again the distance from the centric line to the foot of the

Fig. 14 *Construction of a circle in perspective*
A circle is drawn on the squared surface GFIJ, and the points of intersection between the grid and the circle are noted. The squared surface is drawn in perspective. Points of intersection equivalent to those on the original squared surface are recorded on the perspectival grid, and are joined to produce the circle in perspective (all other labels as in Fig. 11).

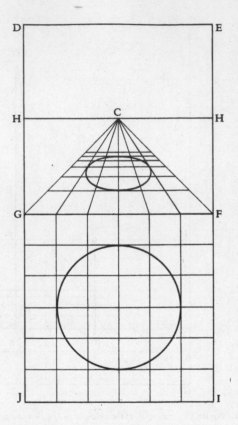

quantity. Thus, by the methods I have described, we can correctly draw all surfaces containing angles.

34. It remains for us to explain how one draws the outlines of circular surfaces. These can be derived from angular surfaces. I do this as follows. I draw a rectangle on a drawing board, and divide its sides into parts like those of the base line of the rectangle of the picture (Fig. 14). Then, by drawing lines from each point of these

divisions to the one opposite, I fill the area with small rectangles. On this I inscribe a circle the size I want, so that the circle and the parallels intersect each other. I note all the points of intersection accurately, and then mark these positions in their respective parallels of the pavement in the picture. But as it would be an immense labour to cut the whole circle at many places with an almost infinite number of small parallels until the outline of the circle were continuously marked with a numerous succession of points, when I have noted eight or some other suitable number of intersections, I use my judgement to set down the circumference of the circle in the painting in accordance with these indications. Perhaps a quicker way would be to draw this outline from a shadow cast by a light, provided the object making the shadow were interposed correctly at the proper place. We have now explained how the larger angular and circular surfaces are drawn with the aid of the parallels. Having completed circumscription, we must now speak of composition. To this end, we must repeat what composition is.

35. Composition is the procedure in painting whereby the parts are composed together in the picture. The great work of the painter is not a colossus but a 'historia', for there is far more merit in a 'historia' than in a colossus.[35] Parts of the 'historia' are the bodies, part of the body is the member, and part of the member is the surface. The principal parts of the work are the surfaces, because from these come the members, from the members the bodies, from the bodies the 'historia', and finally the finished work of the painter. From the composition of surfaces arises that elegant harmony and grace in bodies, which they call beauty. The face which has some surfaces large and others small, some very prominent and others excessively receding and hollow, such as we see in the faces of old women, will be ugly to look at. But the face in which the surfaces are so joined together that pleasing lights pass gradually into agreeable shadows and there are no very sharp angles, we may rightly call a handsome and beautiful face. So in the composition of surfaces grace and beauty must above all be sought. In order to achieve this there seems to me no surer way than to look at Nature and observe long and carefully how she,

the wonderful maker of things, has composed the surfaces in beautiful members. We should apply ourselves with all our thought and attention to imitating her, and take delight in using the veil I spoke of. And when we are about to put into our work the surfaces taken from beautiful bodies, we will always first determine their exact limits, so that we may direct our lines to their correct place.

36. So far we have spoken of the composition of surfaces. Now we must give some account of the composition of members. In the composition of members care should be taken above all that all the members accord well with one another. They are said to accord well with one another when in size, function, kind, colour and other similar respects they correspond to grace and beauty. For, if in a picture the head is enormous, the chest puny, the hand very large, the foot swollen and the body distended, this composition will certainly be ugly to look at. So one must observe a certain conformity in regard to the size of members, and in this it will help, when painting living creatures, first to sketch in the bones, for, as they bend very little indeed, they always occupy a certain determined position. Then add the sinews and muscles, and finally clothe the bones and muscles with flesh and skin. But at this point, I see, there will perhaps be some who will raise as an objection something I said above, namely, that the painter is not concerned with things that are not visible. They would be right to do so, except that, just as for a clothed figure we first have to draw the naked body beneath and then cover it with clothes, so in painting a nude the bones and muscles must be arranged first, and then covered with appropriate flesh and skin in such a way that it is not difficult to perceive the positions of the muscles. As Nature clearly and openly reveals all these proportions, so the zealous painter will find great profit from investigating them in Nature for himself. Therefore, studious painters should apply themselves to this task, and understand that the more care and labour they put into studying the proportions of members, the more it helps them to fix in their minds the things they have learned. I would advise one thing, however, that in assessing the proportions of a

living creature we should take one member of it by which the rest are measured. The architect Vitruvius reckons the height of a man in feet.[36] I think it more suitable if the rest of the limbs are related to the size of the head, although I have observed it to be well-nigh a common fact in men that the length of the foot is the same as the distance from the chin to the top of the head.

37. Having selected this one member, the rest should be accommodated to it, so that there is no member of the whole body that does not correspond with the others in length and breadth. Then we must ensure that all the members fulfil their proper function according to the action being performed. It is appropriate for a running man to throw his hands about as well as his feet. But I prefer a philosopher, when speaking, to show modesty in every limb rather than the attitudes of a wrestler. *The painter Daemon represented an armed man in a race so that you would have said he was sweating, and another taking off his arms, so lifelike that he seemed clearly to be gasping for breath. And someone painted Ulysses in such a way that you could tell he was not really mad but only pretending.*[37] They praise a 'historia' in Rome, in which the dead Meleager is being carried away, because those who are bearing the burden appear to be distressed and to strain with every limb, while in the dead man there is no member that does not seem completely lifeless; they all hang loose; hands, fingers, neck, all droop inertly down, all combine together to represent death.[38] This is the most difficult thing of all to do, for to represent the limbs of a body entirely at rest is as much the sign of an excellent artist as to render them all alive and in action. So in every painting the principle should be observed that all the members should fulfil their function according to the action performed, in such a way that not even the smallest limb fails to play its appropriate part, that the members of the dead appear dead down to the smallest detail, and those of the living completely alive. A body is said to be alive when it performs some movement of its own free will. Death, they say, is present when the limbs can no longer carry out the duties of life, that is, movement and feeling. So the painter who wishes his representations of bodies to appear alive, should see to it that all

their members perform their appropriate movements. But in every movement beauty and grace should be sought after. Those movements are especially lively and pleasing that are directed upwards into the air. We have also said that regard should be had to similarity of kind in the composition of members, for it would be ridiculous if the hands of Helen or Iphigenia looked old and rustic, or if Nestor had a youthful breast and soft neck, or Ganymede a wrinkled brow and the legs of a prize-fighter, or if we gave Milo, the strongest man of all, light and slender flanks. It would also be unseemly to put emaciated arms and hands on a figure in which the face were firm and plump. Conversely, whoever painted Achaemenides discovered on an island by Aeneas with the face Virgil says he had, and the rest of the body did not accord with that face, would certainly be a ridiculous and inept painter.[39] Therefore, every part should agree in kind. And I would also ask that they correspond in colour too; for to those who have pink, white and agreeable faces, dark forbidding breasts and other parts are completely unsuitable.

38. So, in the composition of members, what we have said about size, function, kind and colour should be observed. Everything should also conform to a certain dignity. It is not suitable for Venus or Minerva to be dressed in military cloaks; and it would be improper for you to dress Jupiter or Mars in women's clothes. The early painters took care when representing Castor and Pollux that, though they looked like twins, you could tell one was a fighter and the other very agile. They also made Vulcan's limp show beneath his clothing, so great was their attention to representing what was necessary according to function, kind and dignity.[40]

39. Now follows the composition of bodies, in which all the skill and merit of the painter lies. Some of the things we said about the composition of members pertain also to this, for all the bodies in the 'historia' must conform in function and size. If you painted centaurs in an uproar at dinner, it would be absurd amid this violent commotion for one of them to be lying there asleep from drinking wine.[41] It would also be a fault if at the same distance some men were a great deal bigger than others, or dogs the same

size as horses in your picture. Another thing I often see deserves to be censured, and that is men painted in a building as if they were shut up in a box in which they can hardly fit sitting down and rolled up in a ball. So all the bodies should conform in size and function to the subject of the action.

40. A 'historia' you can justifiably praise and admire will be one that reveals itself to be so charming and attractive as to hold the eye of the learned and unlearned spectator for a long while with a certain sense of pleasure and emotion. The first thing that gives pleasure in a 'historia' is a plentiful variety. Just as with food and music, novel and extraordinary things delight us for various reasons but especially because they are different from the old ones we are used to, so with everything the mind takes great pleasure in variety and abundance. So, in painting, variety of bodies and colours is pleasing. I would say a picture was richly varied if it contained a properly arranged mixture of old men, youths, boys, matrons, maidens, children, domestic animals, dogs, birds, horses, sheep, buildings and provinces; and I would praise any great variety, provided it is appropriate to what is going on in the picture. When the spectators dwell on observing all the details, then the painter's richness will acquire favour. But I would have this abundance not only furnished with variety, but restrained and full of dignity and modesty. I disapprove of those painters who, in their desire to appear rich or to leave no space empty, follow no system of composition, but scatter everything about in random confusion with the result that their 'historia' does not appear to be doing anything but merely to be in a turmoil. Perhaps the artist who seeks dignity above all in his 'historia', ought to represent very few figures; for as paucity of words imparts majesty to a prince, provided his thoughts and orders are understood, so the presence of only the strictly necessary numbers of bodies confers dignity on a picture. *I do not like a picture to be virtually empty, but I do not approve of an abundance that lacks dignity. In a 'historia' I strongly approve of the practice I see observed by the tragic and comic poets, of telling their story with as few characters as possible. In my opinion there will be no 'historia' so rich in variety of things that nine or*

ten men cannot worthily perform it. I think Varro's dictum is relevant here: he allowed no more than nine guests at dinner, to avoid disorder.[42] Though variety is pleasing in any 'historia', a picture in which the attitudes and movements of the bodies differ very much among themselves, is most pleasing of all. So let there be some visible full-face, with their hands turned upwards and fingers raised, and resting on one foot; others should have their faces turned away, their arms by their sides, and feet together, and each one of them should have his own particular flexions and movements. Others should be seated, or resting on bended knee, or almost lying down. If suitable, let some be naked, and let others stand around, who are half-way between the two, part clothed and part naked. But let us always observe decency and modesty. The obscene parts of the body and all those that are not very pleasing to look at, should be covered with clothing or leaves or the hand. Apelles painted the portrait of Antigonus only from the side of his face away from his bad eye.[43] They say Pericles had a rather long, misshapen head, and so he used to have his portrait done by painters and sculptors, not like other people with head bare, but wearing his helmet.[44] Plutarch tells how the ancient painters, when painting kings who had some physical defect, did not wish this to appear to have been overlooked, but they corrected it as far as possible while still maintaining the likeness. Therefore, I would have decency and modesty observed in every 'historia', in such a way that ugly things are either omitted or emended. Lastly, as I said, I think one should take care that the same gesture or attitude does not appear in any of the figures.

41. A 'historia' will move spectators when the men painted in the picture outwardly demonstrate their own feelings as clearly as possible. Nature provides – and there is nothing to be found more rapacious of her like than she – that we mourn with the mourners, laugh with those who laugh, and grieve with the grief-stricken.[45] Yet these feelings are known from movements of the body. We see how the melancholy, preoccupied with cares and beset by grief, lack all vitality of feeling and action, and remain sluggish, their limbs unsteady and drained of colour. In those who mourn,

the brow is weighed down, the neck bent, and every part of their body droops as though weary and past care. But in those who are angry, their passions aflame with ire, face and eyes become swollen and red, and the movements of all their limbs are violent and agitated according to the fury of their wrath. Yet when we are happy and gay, our movements are free and pleasing in their inflexions. *They praise Euphranor because in his portrait of Alexander Paris he did the face and expression in such a way that you could recognize him simultaneously as the judge of the goddesses, the lover of Helen and the slayer of Achilles. The painter Daemon's remarkable merit is that you could easily see in his painting the wrathful, unjust and inconstant, as well as the exorable and clement, the merciful, the proud, the humble and the fierce.*[46] They say the Theban Aristides, the contemporary of Apelles, represented these emotions best of all; and we too will certainly do the same, provided we dedicate the necessary study and care to this matter.[47]

42. The painter, therefore, must know all about the movements of the body, which I believe he must take from Nature with great skill. It is extremely difficult to vary the movements of the body in accordance with the almost infinite movements of the heart. Who, unless he has tried, would believe it was such a difficult thing, when you want to represent laughing faces, to avoid their appearing tearful rather than happy? And who, without the greatest labour, study and care, could represent faces in which the mouth and chin and eyes and cheeks and forehead and eyebrows all accord together in grief or hilarity? All these things, then, must be sought with the greatest diligence from Nature and always directly imitated, preferring those in painting which leave more for the mind to discover than is actually apparent to the eye.[48] Let me here, however, speak of some things concerning movements, partly made up from my own thoughts, and partly learned from Nature. First, I believe that all the bodies should move in relation to one another with a certain harmony in accordance with the action. Then, I like there to be someone in the 'historia' who tells the spectators what is going on, and either beckons them with his hand to look, or with ferocious expression and forbidding glance

challenges them not to come near, as if he wished their business to be secret, or points to some danger or remarkable thing in the picture, or by his gestures invites you to laugh or weep with them. Everything the people in the painting do among themselves, or perform in relation to the spectators, must fit together to represent and explain the 'historia'. They praise Timanthes of Cyprus for the painting in which he surpassed Colotes, because, when he had made Calchas sad and Ulysses even sadder at the sacrifice of Iphigenia, and employed all his art and skill on the grief-stricken Menelaus, he could find no suitable way to represent the expression of her disconsolate father; so he covered his head with a veil, and thus left more for the onlooker to imagine about his grief than he could see with the eye.[49] They also praise in Rome the boat in which our Tuscan painter Giotto represented the eleven disciples struck with fear and wonder at the sight of their colleague walking on the water, each showing such clear signs of his agitation in his face and entire body that their individual emotions are discernible in every one of them.[50] We must, however, deal briefly with this whole matter of movements.

43. Some movements are of the mind, which the learned call dispositions, such as anger, grief, joy, fear, desire and so on. Others are of the body, for bodies are said to move in various ways, as when they grow or diminish, when they fall ill and recover from sickness, and when they change position, and so on. We painters, however, who wish to represent emotions through the movements of limbs, may leave other arguments aside and speak only of the movement that occurs when there is a change of position. Everything which changes position has seven directions of movement, either up or down or to right or left, or going away in the distance or coming towards us; and the seventh is going around in a circle.[51] I want all these seven movements to be in a painting. There should be some bodies that face towards us, and others going away, to right and left. Of these some parts should be shown towards the spectators, and others should be turned away; some should be raised upwards and others directed

downwards. Since, however, the bounds of reason are often exceeded in representing these movements, it will be of help here to say some things about the attitude and movements of limbs which I have gathered from Nature, and from which it will be clear what moderation should be used concerning them. I have observed how in every attitude a man positions his whole body beneath his head, which is the heaviest member of all. And if he rests his entire weight on one foot, this foot is always perpendicularly beneath his head like the base of a column, and the face of a person standing is usually turned in the direction in which his foot is pointing. But I have noticed that the movements of the head in any direction are hardly ever such that he does not always have some other parts of the body positioned beneath to sustain the enormous weight, or at least he extends some limb in the opposite direction like the other arm of a balance, to correspond to that weight. When someone holds a weight on his outstretched hand, we see how, with one foot fixed like the axis of a balance, the rest of the body is counterpoised to balance the weight. I have also seen that the head of a man when standing does not turn upwards further than the point at which the eye can see the centre of the sky, nor sideways further than where the chin touches the shoulder; and at the waist we hardly ever turn so far that we get the shoulder directly above the navel. The movements of the legs and arms are freer, provided they do not interfere with the other respectable parts of the body. But in these movements I have observed from Nature that the hands are very rarely raised above the head, or the elbow above the shoulders, or the foot lifted higher than the knee, and that one foot is usually no further from the other than the length of a foot. I have also seen that, if we stretch our hand upwards as far as possible, all the other parts of that side follow that movement right down to the foot, so that with the movement of that arm even the heel of the foot is lifted from the ground.

44. There are many other things of this kind which the diligent artist will notice, and perhaps those I have mentioned so far are so obvious as to seem superfluous. But I did not leave them out,

because I have known many make serious mistakes in this respect. They represent movements that are too violent, and make visible simultaneously in one and the same figure both chest and buttocks, which is physically impossible and indecent to look at. But because they hear that those figures are most alive that throw their limbs about a great deal, they cast aside all dignity in painting and copy the movements of actors. In consequence their works are not only devoid of beauty and grace, but are expressions of an extravagant artistic temperament. A painting should have pleasing and graceful movements that are suited to the subject of the action. In young maidens movements and deportment should be pleasing and adorned with a delightful simplicity, more indicative of gentleness and repose than of agitation, although Homer, whom Zeuxis followed, liked a robust appearance also in women.[52] The movements of a youth should be lighter and agreeable, with some hint of strength of mind and body. In a man the movements should be more powerful, and his attitudes marked by a vigorous athletic quality. In old men all the movements should be slow and their postures weary, so that they not only hold themselves up on their two feet, but also cling to something with their hands. Finally, each person's bodily movements, in keeping with dignity, should be related to the emotions you wish to express. And the greatest emotions must be expressed by the most powerful physical indications. This rule concerning movements is common to all living creatures. It is not suitable for a plough-ox to have the same movements as Alexander's noble horse Bucephalus. But we might appropriately paint the famous daughter of Inachus, who was turned into a cow, running with head high, feet in the air, and twisted tail.[53]

45. These brief comments must suffice regarding the movement of living creatures. Now I must speak of the way in which inanimate things move, since I believe all the movements I mentioned are necessary in painting also in relation to them. The movements of hair and manes and branches and leaves and clothing are very pleasing when represented in painting. I should like all the seven movements I spoke of to appear in hair. Let it twist

around as if to tie itself in a knot, and wave upwards in the air like flames, let it weave beneath other hair and sometimes lift on one side and another. The bends and curves of branches should be partly arched upwards, partly directed downwards; some should stick out towards you, others recede, and some should be twisted like ropes. Similarly in the folds of garments care should be taken that, just as the branches of a tree emanate in all directions from the trunk, so folds should issue from a fold like branches. In these too all the movements should be done in such a way that in no garment is there any part in which similar movements are not to be found. But, as I frequently advise, let all the movements be restrained and gentle, and represent grace rather than remarkable effort. Since by nature clothes are heavy and do not make curves at all, as they tend always to fall straight down to the ground, it will be a good idea, when we wish clothing to have movement, to have in the corner of the picture the face of the West or South wind blowing between the clouds and moving all the clothing before it. The pleasing result will be that those sides of the bodies the wind strikes will appear under the covering of the clothes almost as if they were naked, since the clothes are made to adhere to the body by the force of the wind; on the other sides the clothing blown about by the wind will wave appropriately up in the air. But in this motion caused by the wind one should be careful that movements of clothing do not take place against the wind, and that they are neither too irregular nor excessive in their extent. So, all we have said about the movements of animate and inanimate things should be rigorously observed by the painter. He should also diligently follow all we have said about the composition of surfaces, members and bodies.

46. We have dealt with two parts of painting: circumscription and composition. It remains for us to speak of the reception of light. In the rudiments we said enough to show what power lights have to modify colours. We explained that, while the genera of colours remain the same, they become lighter or darker according to the incidence of lights and shades; that white and black are the colours with which we express lights and shades in painting; and

that all the other colours are, as it were, matter to which variations of light and shade can be applied. Therefore, leaving other considerations aside, we must explain how the painter should use white and black. Some people express astonishment that the ancient painters Polygnotus and Timanthes used only four colours, while Aglaophon took pleasure in one alone, as if it were a mean thing for those fine painters to have chosen to use so few from among the large number of colours they thought existed, and as if these people believed it the duty of an excellent artist to employ the entire range of colours.[54] Indeed, I agree that a wide range and variety of colours contribute greatly to the beauty and attraction of a painting. But I would prefer learned painters to believe that the greatest art and industry are concerned with the disposition of white and black, and that all skill and care should be used in correctly placing these two. Just as the incidence of light and shade makes it apparent where surfaces become convex or concave, or how much any part slopes and turns this way or that, so the combination of white and black achieves what the Athenian painter Nicias was praised for, and what the artist must above all desire: that the things he paints should appear in maximum relief.[55] They say that Zeuxis, the most eminent ancient painter, was like a prince among the rest in understanding this principle of light and shade.[56] Such praise was not given to others at all. I would consider of little or no virtue the painter who did not properly understand the effect every kind of light and shade has on all surfaces. In painting I would praise – and learned and unlearned alike would agree with me – those faces which seem to stand out from the pictures as if they were sculpted, and I would condemn those in which no artistry is evident other than perhaps in the drawing. I would like a composition to be well drawn and excellently coloured. Therefore, to avoid condemnation and earn praise, painters should first of all study carefully the lights and shades, and observe that the colour is more pronounced and brilliant on the surface on which the rays of light strike, and that this same colour turns more dim where the force of the light gradually grows less. It should also be observed how shadows

always correspond on the side away from the light, so that in no body is a surface illuminated without your finding surfaces on its other side covered in shade. But as regards the representation of light with white and of shadow with black, I advise you to devote particular study to those surfaces that are clothed in light or shade. You can very well learn from Nature and from objects themselves. When you have thoroughly understood them, you may change the colour with a little white applied as sparingly as possible in the appropriate place within the outlines of the surface, and likewise add some black in the place opposite to it. With such balancing, as one might say, of black and white a surface rising in relief becomes still more evident. Go on making similar sparing additions until you feel you have arrived at what is required. A mirror will be an excellent guide to knowing this. I do not know how it is that paintings that are without fault look beautiful in a mirror; and it is remarkable how every defect in a picture appears more unsightly in a mirror. So the things that are taken from Nature should be emended with the advice of the mirror.

47. Let me relate here some things I have learned from Nature. I observed that plane surfaces keep a uniform colour over their whole extent, while the colours of spherical and concave surfaces vary, and here it is lighter, there darker, and elsewhere a kind of in-between colour. This variation of colour in other than plane surfaces presents some difficulty to not very clever painters. But if, as I explained, the painter has drawn the outlines of the surfaces correctly and determined the border of the illuminated portions, the method of colouring will then be easy. He will first begin to modify the colour of the surface with white or black, as necessary, applying it like a gentle dew up to the borderline. Then he will go on adding another sprinkling, as it were, on this side of the line, and after this another on this side of it, and then another on this side of this one, so that not only is the part receiving more light tinged with a more distinct colour, but the colour also dissolves progressively like smoke into the areas next to each other. But you have to remember that no surface should be made so white that you cannot make it a great deal whiter still. Even in represent-

ing snow-white clothing you should stop well on this side of the brightest white. For the painter has no other means than white to express the brightest gleams of the most polished surfaces, and only black to represent the deepest shadows of the night. *And so in painting white clothes we must take one of the four genera of colours which is bright and clear; and likewise in painting, for instance, a black cloak, we must take the other extreme which is not far from the deepest shadow, such as the colour of the deep and darkening sea.* This composition of white and black has such power that, when skilfully carried out, it can express in painting brilliant surfaces of gold and silver and glass. Consequently, those painters who use white immoderately and black carelessly, should be strongly condemned. I would like white to be purchased more dearly among painters than precious stones. It would be a good thing if white and black were made from those pearls Cleopatra dissolved in vinegar, so that painters would become as mean as possible with them, for their works would then be both more agreeable and nearer the truth. It is not easy to express how sparing and careful one should be in distributing white in a painting. *On this point Zeuxis used to condemn painters because they had no idea what was too much.*[57] If some indulgence must be given to error, then those who use black extravagantly are less to be blamed than those who employ white somewhat intemperately; for by nature, with experience of painting, we learn as time goes by to hate work that is dark and horrid, and the more we learn, the more we attune our hand to grace and beauty. We all by nature love things that are distinct and clear. So we must the more firmly block the way in which it is easier to go wrong.

48. We have spoken so far about the use of white and black. But we must give some account also of the kinds of colours. So now we shall speak of them, not after the manner of the architect Vitruvius as to where excellent red ochre and the best colours are to be found, but how selected and well compounded colours should be arranged together in painting.[58] They say that Euphranor, a painter of antiquity, wrote something about colours.[59] This work does not exist now. However, whether, if it was once

written about by others, we have rediscovered this art of painting
and restored it to light from the dead, or whether, if it was never
treated before, we have brought it down from the heavens, let us
go on as we intended, using our own intelligence as we have done
up to now. I should like, as far as possible, all the genera and
species of colours to appear in painting with a certain grace and
amenity. Such grace will be present when colours are placed next
to others with particular care; for, if you are painting Diana
leading her band, it is appropriate for this nymph to be given
green clothes, the one next to her white, and the next red, and
another yellow, and the rest should be dressed successively in a
variety of colours, in such a way that light colours are always next
to dark ones of a different genera. This combining of colours will
enhance the attractiveness of the painting by its variety, and its
beauty by its comparisons. There is a kind of sympathy among
colours, whereby their grace and beauty is increased when they
are placed side by side. If red stands between blue and green, it
somehow enhances their beauty as well as its own. White lends
gaiety, not only when placed between grey and yellow, but
almost to any colour. But dark colours acquire a certain dignity
when between light colours, and similarly light colours may be
placed with good effect among dark. So the painter in his 'historia'
will arrange this variety of colours I have spoken of.

49. There are some who make excessive use of gold, because they
think it lends a certain majesty to painting. I would not praise
them at all. Even if I wanted to paint Virgil's Dido with her
quiver of gold, her hair tied up in gold, her gown fastened with a
golden clasp, driving her chariot with golden reins, and everything
else resplendent with gold, I would try to represent with colours
rather than with gold this wealth of rays of gold that almost
blinds the eyes of the spectators from all angles.[60] Besides the fact
that there is greater admiration and praise for the artist in the use
of colours, it is also true that, when done in gold on a flat panel,
many surfaces that should have been presented as light and gleam-
ing, appear dark to the viewer, while others that should be darker,
probably look brighter. Other ornaments done by artificers that

are added to painting, such as sculpted columns, bases and pediments, I would not censure if they were in real silver and solid or pure gold, for a perfect and finished painting is worthy to be ornamented even with precious stones.

50. So far we have dealt briefly with the three parts of painting. We spoke of the circumscription of smaller and larger surfaces. We spoke of the composition of surfaces, members and bodies. With regard to colours we have explained what we considered applicable to the painter's use. We have, therefore, expounded the whole of painting, which we said earlier on consisted in three things: circumscription, composition and the reception of light.

Book III

51. SEVERAL THINGS, which I do not think should be omitted from these books, still remain to complete the instruction of the painter, so that he may attain all the praiseworthy objects of which we have spoken. Let me now explain them very briefly.

52. The function of the painter is to draw with lines and paint in colours on a surface any given bodies in such a way that, at a fixed distance and with a certain, determined position of the centric ray, what you see represented appears to be in relief and just like those bodies. The aim of the painter is to obtain praise, favour and good-will for his work much more than riches. The painter will achieve this if his painting holds and charms the eyes and minds of spectators. We explained how this may be done when talking above about composition and the reception of light. But in order that he may attain all these things, I would have the painter first of all be a good man, well versed in the liberal arts. Everyone knows how much more effective uprightness of character is in securing people's favour than any amount of admiration for someone's industry and art. And no one doubts that the favour of many people is very useful to the artist for acquiring reputation and wealth. It so happens that, as rich men are often moved by kindness more than by expert knowledge of art, they will give money to one man who is especially modest and good, and spurn another who is more skilled but perhaps intemperate. For this reason it behoves the artist to be particularly attentive to his morals, especially to good manners and amiability, whereby he

may obtain both the good-will of others, which is a firm protection against poverty, and money, which is an excellent aid to the perfection of his art.

53. I want the painter, as far as he is able, to be learned in all the liberal arts, but I wish him above all to have a good knowledge of geometry. I agree with the ancient and famous painter Pamphilus, from whom young nobles first learned painting; for he used to say that no one could be a good painter who did not know geometry.[61] Our rudiments, from which the complete and perfect art of painting may be drawn, can easily be understood by a geometer, whereas I think that neither the rudiments nor any principles of painting can be understood by those who are ignorant of geometry. Therefore, I believe that painters should study the art of geometry. Next, it will be of advantage if they take pleasure in poets and orators, for these have many ornaments in common with the painter. Literary men, who are full of information about many subjects, will be of great assistance in preparing the composition of a 'historia', and the great virtue of this consists primarily in its invention. Indeed, invention is such that even by itself and without pictorial representation it can give pleasure. The description that Lucian gives of Calumny painted by Apelles, excites our admiration when we read it.[62] I do not think it is inappropriate to tell it here, so that painters may be advised of the need to take particular care in creating inventions of this kind. In the painting there was a man with enormous ears sticking out, attended on each side by two women, Ignorance and Suspicion; from one side Calumny was approaching in the form of an attractive woman, but whose face seemed too well versed in cunning, and she was holding in her left hand a lighted torch, while with her right she was dragging by the hair a youth with his arms outstretched towards heaven. Leading her was another man, pale, ugly and fierce to look upon, whom you would rightly compare to those exhausted by long service in the field. They identified him correctly as Envy. There are two other women attendant on Calumny and busy arranging their mistress's dress; they are Treachery and Deceit. Behind them comes Repentance clad in mourning and

rending her hair, and in her train chaste and modest Truth. If this 'historia' seizes the imagination when described in words, how much beauty and pleasure do you think it presented in the actual painting of that excellent artist?

54. What shall we say too about those three young sisters, whom Hesiod called Egle, Euphronesis and Thalia?[63] The ancients represented them dressed in loose transparent robes, with smiling faces and hands intertwined; they thereby wished to signify liberality, for one of the sisters gives, another receives and the third returns the favour, all of which degrees should be present in every act of perfect liberality. You can appreciate how inventions of this kind bring great repute to the artist. I therefore advise the studious painter to make himself familiar with poets and orators and other men of letters, for he will not only obtain excellent ornaments from such learned minds, but he will also be assisted in those very inventions which in painting may gain him the greatest praise. The eminent painter Phidias used to say that he had learned from Homer how best to represent the majesty of Jupiter.[64] I believe that we too may be richer and better painters from reading our poets, provided we are more attentive to learning than to financial gain.

55. Very often, however, ignorance of the way to learn, more than the effort of learning itself, breaks the spirit of men who are both studious and anxious to do so. So let us explain how we should become learned in this art. The fundamental principle will be that all the steps of learning should be sought from Nature: the means of perfecting our art will be found in diligence, study and application. I would have those who begin to learn the art of painting do what I see practised by teachers of writing. They first teach all the signs of the alphabet separately, and then how to put syllables together, and then whole words. Our students should follow this method with painting.[65] First they should learn the outlines of surfaces, then the way in which surfaces are joined together, and after that the forms of all the members individually; and they should commit to memory all the differences that can exist in those members, for they are neither few nor insignificant.

Some people will have a crook-backed nose; others will have flat, turned-back, open nostrils; some are full around the mouth, while others are graced with slender lips, and so on: every part has something particular which considerably alters the whole member when it is present in greater or lesser degree. Indeed we see that those same members which in our boyhood were rounded, and, one might say, well turned and smoothed, are become rough and angular with the advance of age. All these things, therefore, the student of painting will take from Nature, and assiduously meditate upon the appearance of each part; and he will persist continually in such inquiry with both eye and mind. In a seated figure he will observe the lap, and how the legs hang gently down. In a standing person he will note the whole appearance and posture, and there will be no part whose function and symmetry, as the Greeks call it, he will not know.[66] But, considering all these parts, he should be attentive not only to the likeness of things but also and especially to beauty, for in painting beauty is as pleasing as it is necessary. The early painter Demetrius failed to obtain the highest praise because he was more devoted to representing the likeness of things than to beauty.[67] Therefore, excellent parts should all be selected from the most beautiful bodies, and every effort should be made to perceive, understand and express beauty. Although this is the most difficult thing of all, because the merits of beauty are not all to be found in one place, but are dispersed here and there in many, every endeavour should none the less be made to investigate and understand it thoroughly. The man who has learned to grasp and handle more serious matters, will in my view easily manage the less troublesome, and there is nothing so difficult that cannot be overcome by application and persistent effort.

56. Yet, in order that our effort shall not be vain and futile, we must avoid the habit of those who strive for distinction in painting by the light of their own intelligence without having before their eyes or in their mind any form of beauty taken from Nature to follow. They do not learn to paint properly, but simply make habits of their mistakes. The idea of beauty, which the most

expert have difficulty in discerning, eludes the ignorant. Zeuxis, the most eminent, learned and skilled painter of all, when about to paint a panel to be publicly dedicated in the temple of Lucina at Croton, did not set about his work trusting rashly in his own talent like all painters do now; but, because he believed that all the things he desired to achieve beauty not only could not be found by his own intuition, but were not to be discovered even in Nature in one body alone, he chose from all the youth of the city five outstandingly beautiful girls, so that he might represent in his painting whatever feature of feminine beauty was most praise-worthy in each of them.[68] He acted wisely, for to painters with no model before them to follow, who strive by the light of their own talent alone to capture the qualities of beauty, it easily happens that they do not by their efforts achieve the beauty they seek or ought to create; they simply fall into bad habits of painting, which they have great difficulty in relinquishing even if they wish. But the painter who has accustomed himself to taking everything from Nature, will so train his hand that anything he attempts will echo Nature. We can see how desirable this is in painting when the figure of some well-known person is present in a 'historia', for although others executed with greater skill may be conspicuous in the picture, the face that is known draws the eyes of all spectators, so great is the power and attraction of something taken from Nature. So, let us always take from Nature whatever we are about to paint, and let us always choose those things that are most beautiful and worthy.

57. We must beware, however, not to paint on very small panels, as many do. I would have you get used to making large pictures, which are as near as possible in size to the actual object you wish to represent. In small pictures the greatest mistakes are most easily concealed; in a large one even the smallest errors are obvious. Galen wrote that he had seen carved on a ring Phaethon driving four horses, with their reins and feet and breasts clearly visible.[69] But painters should leave this distinction to the sculptors of precious stones, and occupy themselves instead in larger fields of fame. The man who has learned to make or paint large figures

would at once do small things of this kind easily and well; whereas the man who has accustomed his hand and talent to these tiny jewels, will easily go wrong in larger works.

58. There are some who imitate the work of other painters and thereby aspire to fame. They say that the sculptor Calamis did this: he engraved two cups in which he so closely copied Zenodorus that no difference could be recognized between their works.[70] But painters are gravely mistaken if they do not understand that those who painted in the past endeavoured to represent a likeness such as we see depicted by Nature on our veil. If it is a help to imitate the works of others, because they have greater stability of appearance than living things, I prefer you to take as your model a mediocre sculpture rather than an excellent painting, for from painted objects we train our hand only to make a likeness, whereas from sculptures we learn to represent both likeness and correct incidence of light. In studying such light it is very useful to dim your vision by half closing your eyelashes, so that the light appears less strong and almost as if depicted on an intersection. It will probably help also to practise at sculpting rather than painting, for sculpture is easier and surer than painting. No one will ever be able to paint a thing correctly if he does not know its every relief, and relief is more easily found by sculpture than by painting. No mean proof of this lies in the observation that in almost all ages you will find there were some mediocre sculptors, but scarcely any painters who were not ridiculous and completely incompetent.

59. Whether you practise painting or sculpture, you should always have before you some fine and remarkable model which you observe and copy; and in copying it I believe that diligence should be combined with speed of execution, but in such a way that the painter will never apply his brush or style to his work before he has clearly decided in his own mind what he is going to do and how he will do it. It is safer to remove errors with the mind than to erase them from one's work. Besides, when we have acquired the habit of doing everything in orderly fashion, we shall become faster workers by far than Asclepiodorus, who they say was the

fastest painter of all.[71] Talent roused and stimulated by practice turns easily and readily to work, and the hand swiftly follows when guided by a sure and ordered judgement. If there are slow artists, they are so because they try slowly and lingeringly to do something which they have not first thought out clearly in their own minds; as they wander, fearful and virtually sightless, in the darkness of their error, like the blind man with his stick they with their brush test and investigate unknown paths and exits. Therefore he should never put his hand to work without the guidance of well-informed judgement.

60. As the most important part of the painter's work is the 'historia', in which there should be every abundance and beauty of things, we should take care to learn to paint well, as far as our talent allows, not only the human figure but also the horse, the dog and other living creatures, and every other object worthy to be seen. In this way, variety and abundance, without which no 'historia' merits praise, will not be lacking in our works. It is a tremendous gift, and one not granted to any of the ancients, for a man to be, I will not say outstanding, but even moderately learned in everything. Yet I think every effort should be made to see that we do not lack through our own negligence those things which bring high praise if they are achieved, and blame if they are neglected. The Athenian painter Nicias painted women very well; *but they say that Zeuxis far excelled all others in painting the female body.* Heraclides was famous for painting ships. Serapion was incapable of painting men, but he did all other things splendidly. Dionysius could not do anything but men. The Alexander who painted the portico of Pompeius, was excellent at doing all the quadrupeds and especially dogs. Because he was always in love, Aurelius delighted only in painting goddesses and giving their portraits the faces of his mistresses. Phidias endeavoured to represent the majesty of the gods rather than the beauty of men. The representation of the dignity of illustrious men most pleased Euphranor, and in this he excelled all others.[72] And so each one had a different ability. Nature gave to each mind its own gifts; but we should not be so content with these that we leave unattempted

whatever we can do beyond them. The gifts of Nature should be cultivated and increased by industry, study and practice, and nothing which pertains to glory ought to be overlooked and neglected by us.

61. When we are about to paint a 'historia', we will always ponder at some length on the order and the means by which the composition might best be done. We will work out the whole 'historia' and each of its parts by making preparatory studies on paper, and take advice on it with all our friends. We will endeavour to have everything so well worked out beforehand that there will be nothing in the picture whose exact collocation we do not know perfectly. In order that we may know this with greater certainty, it will help to divide our preparatory studies into parallels, so that everything can then be transferred, as it were, from our private papers and put in its correct position in the work for public exhibition.[73] In carrying out our work we will employ the necessary diligence combined with speed, so that tedium does not prevent us from going on, nor eagerness to complete make us rush the job. From time to time we should interrupt our work and refresh our minds, and not do what many do, and take on several works at once, starting on one and setting another on one side unfinished. Whatever works you begin should be completed in every respect. When someone showed him a picture, saying: 'I painted this just now', Apelles replied: 'That is obvious without your saying so; I am only surprised you did not manage several more like it.'[74] I have seen some painters and sculptors, and rhetoricians and poets as well (if in our day and age there are any worth calling rhetoricians or poets), begin some work with great enthusiasm, and then when the ardour of their thoughts cooled, abandon it in a rough and unfinished state, and under impulse to do something different, devote themselves to fresh enterprises. I certainly disapprove of such people. All who wish their works to be pleasing and acceptable to posterity, should first think well about what they are going to do, and then carry it out with great diligence. Indeed diligence is no less welcome than native ability in many things. But one should avoid the excessive scruple of

those who, out of desire for their work to be completely free from all defect and highly polished, have it worn out by age before it is finished. The ancient painters used to criticize Protogenes because he could not take his hand off his painting.[75] And rightly so, for we should certainly strive to employ every care needed in our work, as far as our talents permit, but wanting to achieve in every particular more than is possible or suitable is characteristic of a stubborn, not of a diligent man.

62. Therefore, a moderate diligence should be employed. Friends should be consulted, and while the work is in progress, any chance spectators should be welcomed and their opinion heard. The painter's work is intended to please the public. So he will not despise the public's criticism and judgement when he is still in a position to meet their opinion. They say that Apelles used to hide behind his painting, so that the viewers could speak more freely, and he could more decently listen to them enumerating the defects of his work.[76] So I want our painters openly and often to ask and listen to everybody's opinion, since it helps the painter, among other things, to acquire favour. There is no one who does not think it an honour to express his opinion on someone else's work. Nor is there any need to fear that the judgement of censorious and envious critics can in any way detract from the merit of the painter. His fame is open and known to all, and his own good painting is eloquent witness to it. So he should listen to everyone, and first reflect on the matter for himself, making any necessary amendments; then, when he has heard everybody, he should follow the advice of the more expert.

63. This is all I had to say about painting in these books. If it is such as to be of some use and convenience to painters, I would especially ask them as a reward for my labours to paint my portrait in their 'historiae', and thereby proclaim to posterity that I was a student of this art and that they are mindful of and grateful for this favour. If, however, I have not fulfilled their expectations, they should not censure me for having dared to attempt such an important subject. For, if my ability was unequal to completing what was praiseworthy to attempt, they should remember that in

matters of great importance the very desire to achieve what was most difficult is usually regarded as worthy of praise. There will probably be some who will correct my mistakes and who will be of far greater assistance to painters than me in this excellent and honourable art. I implore them, should they in future exist, to take up this task eagerly and readily, to exercise their talents on it, and perfect this most noble art. I consider it a great satisfaction to have taken the palm in this subject, as I was the first to write about this most subtle art. If I have not succeeded in accomplishing this undoubtedly difficult task to the satisfaction of the reader, Nature is more to blame than me, as she imposed the law that no art exists that did not begin from faulty origins. Nothing, they say, was born perfect.[77] If they are superior to me in ability and application, my successors will probably make the art of painting complete and perfect.

Explanatory Notes

1. Filippo di Ser Brunellesco, known as Brunelleschi (1377–1446), goldsmith, sculptor, architect, engineer and inventor; Donato di Niccolò di Betto Bardi, known as Donatello (*c.* 1386–1466), sculptor; Lorenzo (Nencio) di Cione Ghiberti (1378–1455), sculptor and architect; Luca di Simone della Robbia (*c.* 1400–82), sculptor; Tommaso di Giovanni di Simone Guidi, known as Masaccio (1401–28), painter.

2. The Dome of Florence Cathedral was constructed between 1420 and 1436. See H. Saalman, *Filippo Brunelleschi. The Dome of Santa Maria del Fiore*, London, 1980.

3. The Italian text – 'mi piacerà rivegga questa mia opera *de pictura* quale a tuo nome feci in lingue toscana' – might imply that Brunelleschi was already acquainted with the Latin text.

4. Giovan Francesco Gonzaga, Marquis of Mantua (1407–44), whose son, Lodovico, was to become a major patron of Alberti's architecture, including the churches of S. Sebastiano and S. Andrea.

5. For Alberti's Ciceronian expression, 'Minerva', see the Introduction, p. 12.

6. The Latin reads: 'Una quidem quae per extremum illum ambitum quo superficies clauditur noscat, quem quidem ambitum nonulli horizontem nuncupant; nos si liceat, latin vocabulo similitudine quadam appellamus oram aut, dum ita libeat, fimbriam.' Alberti uses a number of terms to indicate 'boundary', 'borderline', 'contour', 'edge', 'outline', etc.: *ambitum, discrimen, extremitas, horizontem, fimbria, ora, rimula, terminus*.

7. The Italian text at this point informs us that 'more could be said about these reflections, which relate to those miracles of painting which many of my friends have seen made by me previously in Rome'. This suggests that his 'miracles of painting' involved mirrors in some kind of peep show. See below, Note 15. For the sources of the optics in the preceding passages on reflections, the visual pyramid, colours, etc., see the Introduction, pp. 10–13, and M. Kemp, *The Science of Art. Optical Themes in Western Art from Brunelleschi to Seurat*, New Haven and London, 1990, pp. 20–26 and 264–6.

8. Aulus Gellius, *Noctium Atticarum*, I, i, 1–3, citing Plutarch.

9. Virgil, *Aeneid*, III, 655–8.

10. Virgil, *Aeneid*, IX, 177–448.

11. Protagoras's axiom, much quoted and variously used by Alberti, was probably known to him from Diogenes Laertius, *De Vitis . . . philosophorum*, IX, 51.

12. Pliny, *Historia naturalis*, XXXV, 74. Alberti's protégé, Cristoforo Landino, was to translate Pliny into Italian: *Historia naturale . . .*, Venice, 1476.

13. The *braccio* in Florence was equivalent to about 58 centimetres or 23 inches.

14. *Superbipartiens* is the mathematical term for the ratio 3:5.

15. The 'miracles' are described more fully in the anonymous *Vita* in *Opere volgari*, ed. Bonucci, pp. cii–ciii: 'the pictures, which were contained in a very small box, were seen through a tiny aperture. There you were able to see very high mountains and broad landscapes around a wide bay of sea, and, furthermore, regions removed very distantly from sight, so remote as not to be clearly seen by the viewer. He called these things "demonstrations" . . . he called one of them "daytime" and the other "nighttime".' See also above, Note 7.

16. His *Elementa picturae* (*Elementi di pittura*) in *Opere volgari*, ed. Grayson, III, pp. 108–29, which contains basic geometrical definitions and instructions on the drawing of geometrical figures on the foreshortened 'pavement', does not meet the need to show how the pyramid results in the pictorial construction.

17. Plutarch, *Alexander*, LXXIV, 4, and *Agesilaus*, II, 2.

18. Quintilian, *De Institutio oratoria*, 12, 10, 9.

19. Pliny, *Historia naturalis*, XXXV, 62.

20. Quintilian, *Institutio oratoria*, 10, 2, 7.

21. Pliny, *Historia naturalis*, XXXV, 16, 15 and 22.

22. For Euphranor, Antigonous, Xenocrates and Apelles, see Pliny, *Historia naturalis*, XXXV, 129, 68, 79 and 111. For Demetrius, see Diogenes Laertius, *De Vitis . . . philosophorum*, V, 83.

23. *Asclepius*, III, in W. Scott, *Hermetica*, Vol. I, Oxford, 1924, p. 339, 23b. Compare Lactanius, *De Divinis institutionibus*, 2, 10, 3–15.

24. For Aristedes and Protogenes, see Pliny, *Historia naturalis*, XXXV, 100 and 105.

25. Pliny, *Historia naturalis*, XXXV, 19–20, though the reference to Manilius has not been traced.

26. Socrates in Pliny, *Historia naturalis*, XXXV, 137 and XXXVI, 32; Plato in Diogenes Laertius, *Die Vitis . . . philosophorum*, III, 4–5; Metrodorus, Pliny, XXXV, 135; Pyrrho, Diogenes Laertius, IX, 61.

27. Nero in Suetonius, *Nero*, 52, and Tacitus, *Annales*, XIII, 3; Valentinianus in Ammianus Marcellinus, *Rerum gestarum*, XXX, 9, 4; Alexander Severus in Lampridius, *Alexander Severus*, 27.

28. Pliny, *Historia naturalis*, XXXIV, 27, and Diogenes Laertius, *De Vitis . . philosophorum*, V, 75.

29. Pliny, *Historia naturalis*, XXXV, 135.

30. Possibly a misunderstanding of Pliny, *Historia naturalis*, XXXV, 147: 'Iaia Cyzicena, perpetua virgo, M. Varronis iuventa Romae . . . pinxit.'

31. For such images, see H. W. Janson, 'The Image Made by Chance in Renaissance Thought', *Essays in Honour of Erwin Panofsky*, ed. M. Meiss, New York, 1961, pp. 145–66.

32. Pliny, *Historia naturalis*, XXXVII, 5.

33. Xenophon, *Memorabilia*, III, x.

34. Pliny, *Historia naturalis*, XXXV, 81–3, on the famous story of how the rivals strove to draw a line finer than the other. See E. H. Gombrich, 'The Heritage of Apelles', in *The Heritage of Apelles*, Oxford, 1976, pp. 3–18.

35. The term *historia* is roughly equivalent to what later academic theorists would call 'history painting', that is to say, a human narrative drawn from some significant secular or Christian story. Alberti's use may also include allegorical representations and perhaps also such devotional images as the Virgin in company with the saints. For ancient *colossi*, see Pliny, *Historia naturalis*, XXXIV, 39–46, and XXXV, 51.

36. Vitruvius, *De Architectura*, III, 1.

37. A misreading of Pliny, *Historia naturalis*, XXXV, 71, where this painting is in fact attributed to Parrhasius.

38. A number of ancient reliefs of the *Carrying of the Body of Meleager* were known in the Renaissance. See P. P. Bober and R. O. Rubenstein, *Renaissance Artists and Antique Sculpture*, Oxford, 1986, nos. 117–18.

39. Virgil, *Aeneid*, III, 588ff.

40. Cicero, *De Natura deorum*, I, xxx, 83.

41. The battle of the lapiths and centaurs as narrated by (amongst others) Ovid, *Metamorphoses*, XII, 210 ff, and as later sculpted by Michelangelo (Florence, Casa Buonarroti).

42. Aulus Gellius, *Nocium atticarum*, XIII, xi, 2–3.

43. Pliny, *Historia Naturalis*, XXXV, 90, and Quintilian, *Institutio oratoria*, II, xii, 12, as Piero della Francesca was later to do in his portraits of Federigo da Montefeltro.

44. Plutarch, *Pericles*, III, 2.

45. Alberti's expression – 'qua nihil sui similium rapacius inveniri potest' – is derived from Cicero, *De amicitia*, 14,50.

46. Euphranor and Daemon in Pliny, *Historia naturalis*, XXXV, 77 and 69, though the reference to Deamon results from a misunderstanding (see above, Note 37).

47. Pliny, *Historia naturalis*, XXXV, 98–100.

48. Compare Pliny, *Historia naturalis*, XXXV, 68.

49. Quintilian, *Institutio oratoria*, 2, 13, 13: Compare Pliny, *Historia naturalis*, XXXV, 73, and Cicero, *Orator*, XXII, 74.

50. Giotto's mosaic of the *Navicella*, depicting Christ and St Peter walking on the

water (over the entrance to old St Peter's in Rome) was one of the most famous exemplars of narrative art during the fourteenth and fifteenth centuries, but was destroyed in the seventeenth century.

51. As described in Quintilian, *Institutio oratoria*, 11, 3, 105.

52. Quintilian, *Institutio oratoria*, 12, 10, 5.

53. That is to say, Io, as in Ovid, *Metamorphoses*, I, 583 ff.

54. For Polygnotus and Timanthes (and Zeuxis), see Cicero, *Brutus*, XVIII, 70; compare Pliny, *Historia naturalis*, XXXV, 50, where Apelles, Aetion, Melanthius and Nicomachus are said to have used four colours; for Aglaophon, see Quintilian, *Institutio oratoria*, 12, 10, 3. See also J. Gage, 'A Locus Classicus of Colour Theory. The Fortunes of Apelles', *Journal of the Warburg and Courtauld Institutes*, XLIV, 1981, pp. 1–26.

55. Pliny, *Historia naturalis*, XXXV, 131.

56. Quintilian, *Institutio oratoria*, 12, 10, 5.

57. Cicero, *Orator*, XXII, 73, but citing Apelles not Zeuxis.

58. Vitruvius, *De Architectura*, VII, vii.

59. Pliny, *Historia naturalis*, XXXV, 129.

60. Virgil, *Aeneid*, IV, 125 ff.

61. Pliny, *Historia naturalis*, XXXV, 76–7.

62. Lucian, *De Calumnia*, 5. Alberti used the translation by Guarino da Verona. The opportunity to recreate Apelles's famous painting was seized by a number of subsequent artists, most notably Botticelli (Florence, Uffizi). See D. Cast, *The Calumny of Apelles. A Study in the Humanist Tradition*, New Haven and London, 1981; and J. M. Massing, *Du texte à l'image. La Calomnie d'Apelle et son iconographie*, Strasbourg, 1990.

63. Particularly Seneca, *De Beneficiis*, 1, 3, 2–7, although Alberti refers to Aglaia as 'Egle'. Compare the 'Three Graces' in Botticelli's *Primavera* (Florence, Uffizi).

64. Strabo, *Geographia*, VIII, 3, 30.

65. This method of starting with the formal 'elements', as Quintilian recommended for rhetoric, is satisfied in part by his own *Elementa picturae* (see Note 16).

66. *Symmetria*, the Greek term, is used by Pliny, *Historia naturalis*, XXXIV, 65, and carries implications of proportion beyond our more limited sense of the symmetrical.

67. Quintilian, *Institutio oratoria*, 12, 10, 9.

68. Cicero, *De Inventione*, II, 1, 1–3, and Pliny, *Historia naturalis*, XXXV, 64.

69. Galen, *De Usu partium*, XVII, 1.

70. Pliny, *Historia naturalis*, XXXIV, 47, where Zenodorus copies Calamis.

71. Pliny, *Historia naturalis*, XXXV, 109, but attributing speed to Nicomachus, while Asclepiodorus is discussed in a preceding passage (107).

72. For Nicias, Zeuxis, Eraclides, Serapion, Dionysius, Aurelius, Phidias and Euphranor, see Pliny, *Historia naturalis*, XXXV, 129, 64, 135, 113, 119, 54, XXXVI, 18–19, and XXXV, 128. The reference to Alexander has not been traced.

EXPLANATORY NOTES

73. Alberti's expression *modulos in parallelos dividere* (Italian, *segneremo i modelli nostri con paraleli*) should be understood in the sense of preparatory studies that are squared for transfer on to a larger scale. The grid incised in the plaster on which the head of the Virgin has been painted in Masaccio's *Trinity* is an early example of such a procedure. The use of squared *modelli* later became common, e.g. in Raphael's design processes.
74. Plutarch, *De Liberis educandis*, 7.
75. Pliny, *Historia naturalis*, XXXV, 80.
76. Pliny, *Historia naturalis*, XXXV, 84–5.
77. Cicero, *Brutus*, XVIII, 71.

PENGUIN ONLINE

read about your favourite authors

•

investigate over 12,000 titles

•

browse our online magazine

•

enter one of our literary quizzes

•

win some fantastic prizes in our competitions

•

e-mail us with your comments and book reviews

•

instantly order any Penguin book

'To be recommended without reservation ... a rich and rewarding online experience' *Internet Magazine*

www.penguin.com